The FOCALGUIDE to the 35mm Single Lens Reflex

Leonard Gaunt

Focal Press Limited, London

Focal Press Inc, New York

ISBN 0 240 50768 1

First edition 1973
Second impression 1974
Third impression 1975
Fourth impression 1976
Fifth impression 1976
Sixth impression 1977
Seventh impression (with revisions) 1978
Eighth impression (with revisions) 1980

Spanish edition
LA REFLEX DE UN SOLO OBJETIVO DE 35mm.
Ediciones Omega SA. Barcelona

Printed and bound in Great Britain by Maund and Irvine Ltd. Tring, Herts.

Contents

The Versatile Camera

Your choice of a 35 mm single lens reflex (SLR) camera for day-to-day use on a variety of subjects is a wise one. No other type of camera can tackle such a wide range of photographic subjects and produce, at worst, a reasonably good result. For many subjects, it is the only practicable type.

The advantages of the SLR stem partly from the film it uses and partly from the ingenious design of the camera itself. The film is 35 mm wide and is generally sold in lengths of about 150 cm (5 ft) that provide 36 pictures. Shorter lengths (20 pictures) and bulk supplies (5 m and 17 m) are also easily obtained. The cost per negative or colour transparency is much lower than with the larger films. That advantage is, however, common to all 35 mm cameras.

Interchangeable lens facilities

The SLR has advantages specifically its own. The most obvious advantage is that nearly all SLRs are now made in such a way that the entire lens can be removed and replaced by another. You can use lenses of short focal length to take in a wide-angle view, or lenses of longer focal length to give a magnified image of a distant view. That, too, is possible with non-reflex cameras, but the range of applications following therefrom is much narrower because of the more restrictive method of viewing and focusing. The viewfinder image in the SLR is provided by the camera lens and it can be focused visually by adjusting the lens. In the non-reflex, the viewfinder image is provided by a separate optical system and focusing is by yet another system. The non-reflex focusing system can be linked to the lens focusing movement, but only with a rather limited range of lenses. Moreover, every time you change the lens, you have to change the viewfinder, although a few cameras have automatic adjustment or masking of the viewfinder image.

The SLR viewfinder shows the image that will appear on the film, no matter what lens or attachment you use. It shows just what the lens sees and whether the image is sharp or out of focus. It lets you see the effect you get by focusing at various distances or using different aperture settings (see page 23).

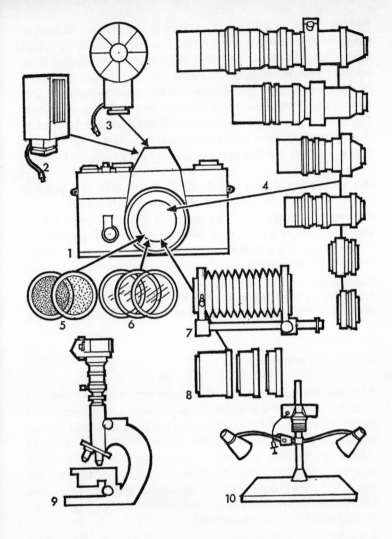

Elements of the SLR system: 1, Camera body with standard lens. 2, Electronic flash unit. 3, Bulb flashgun. 4, Interchangeable lenses. 5, Filters. 6, Close-up lenses. 7, Extension bellows. 8, Extension tubes. 9, Microscope and adaptor. 10, Copy stand.

11

Perhaps the most striking advantages of the SLR are its uses at long and short range. Because the viewfinder shows the actual image that will appear on the film, formed by the camera lens, you can work to the absolute limits. You can shoot right down to the closest point that a lens can be made to focus at and right out to even farther than you can see with the unaided eye. These limits are set only by the equipment available because at close range you can use microscope objectives and at long range you can use the most powerful lens produced for your camera.

The non-reflex camera can do this type of work satisfactorily only when it uses an attachment that converts it to a reflex.

Between the extremes of very long and very short focus lenses you have the normal run of lenses of various focal lengths which allow you a choice of various sizes af image at normal shooting distances, and additional equipment such as extension tubes and bellows (see page 120) to enable you to focus at closer range than the lens normally allows. Hence, the claim that the SLR can handle almost any photographic assignment.

Built-in accessories

Naturally, the SLR has all the advantages of other 35 mm cameras to add to its own. It has tended to grow larger over the years, but is still a camera that is easily carried around and that can be brought into action rapidly. Most models have a full range of shutter speeds (see page 32) from one second to 1/1000 sec and can thus shoot rapidly moving subjects or less mobile subjects in very poor light. Innumerable lens manufacturers have produced first-class lenses to supplement the range offered by the manufacturer of the camera.

Exposure meters of various types are often built into the camera to simplify the choice of appropriate shutter speeds and apertures to ensure accurate colour reproduction or adequate separation of tones in a black-and-white negative. Again, the SLR has an advantage here because its design makes it possible for the light sensitive cell of the exposure meter to take its reading through the camera lens. Hence, the further popular

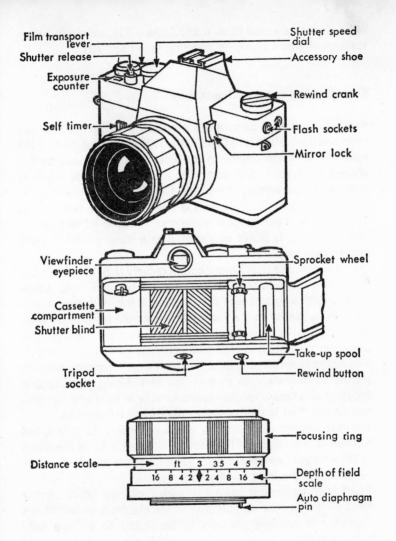

Features of the 35mm single lens reflex. The pentaprism housing gives most models a distinctive appearance.

abbreviation attached to so many SLRs – TTL, which indicates through-the-lens exposure metering (see page 70).

Overcoming the disadvantages

Every modern SLR camera has a shutter synchronised for use with electronic flash and flashbulbs. This simply means that the electrical contacts operating the flash unit are closed by the shutter movement to ensure that the shutter blinds are fully separated (uncovering the whole film area) while the flash is emitting all its useful light. This is one department, however, in which the SLR with a focal plane shutter has to admit to slight disadvantages. It is not as versatile as a camera with a blade shutter (see page 136).

The blade shutter SLR is now comparatively rare, because it has inherent disadvantages that just cannot be eliminated. Large blade shutters are not easy to make, and if this design of shutter were to be placed in the focal plane it would need to be large and would need more room to operate than the average SLR body can provide. It is therefore generally placed either within a completely detachable lens, in which case a separate capping shutter is necessary to protect the film during viewing and focusing and lens-changing operations, or in front of a rear lens component that is permanently attached to the camera.

The first alternative makes the lenses expensive. Each lens has to have its own shutter. The second alternative limits the range of lenses available because the focal length is changed merely by changing the front component.

Apart from its greater versatility with flash, the blade shutter fixed in the camera complete with iris diaphragm also allows shutter and aperture controls to be linked to provide fully automatic exposure systems. You simply set the shutter speed and the iris setting is controlled by the meter.

SLR manufacturers were slow to overcome the difficulties of introducing automatic exposure in cameras that allowed no physical connection between shutter speed and aperture controls. Their normal coupled-exposure meters, particularly the TTL types, seemed to be all that was needed. Gradually,

however, they came round to the idea and there was a sudden spurt of activity in 1973 and 1974 which brought highly sophisticated electronic circuitry into camera design to produce automatic exposure models of various designs (see page 233).

Thus, slowly but surely, the SLR is pushing the non-reflex camera into the background – at least in the quality camera field. The non-reflex design of 35 mm camera is being forced into the low and middle price ranges and into newer more compact designs to compete with the admitted bulk of many reflexes.

Viewing and Focusing

Probably, the first thing you do with your new SLR camera is to look into the viewfinder eyepiece. If this is your first sight of an SLR viewfinder image, you get quite a surprise. The image looks large. In fact, if you keep both eyes open, you will see that the viewfinder image seen with one eye and the actual subject seen with the other eye are near enough the same size — provided the lens on the camera is of the standard 50 mm focal length or thereabouts.

Making best use of the viewfinder

This large image enables you to see every part of your subject clearly and to examine it carefully to make sure that you have a picture in view and not just a casual, disorganised glance at the subject in front of you. There is quite a difference between these two aspects because, if you just point your camera and shoot as soon as you see something worth photographing, it is unlikely that you are making the most of your opportunities. You may even be spoiling the picture simply by the lack of a little care.

It is rather unlikely, for example, that you will find the best viewpoint entirely by chance. If you are photographing a landscape, you generally require some unifying theme (such as a pattern of shapes) or a prominent feature to hold the interest, or perhaps a foreground object to camouflage an empty space or set the scale. The viewpoint can influence the shapes or their relationships one to another. It can affect the placing and size of any particular feature. It always pays to study the subject carefully and to move around it as much as possible to find the viewpoint that presents the subject as you wish to show it.

While seeking your viewpoint in this way, you should constantly check your impressions in the viewfinder. A scene that the ranging eye sees as superb often looks rather less impressive when the fixed eye of the camera compresses it all into a flat, two-dimensional area with a rigid boundary. On the other hand, a not-too-interesting general view can often contain small parts that a closer approach might transform into striking pictures.

You should always bear the two-dimensional aspect of your

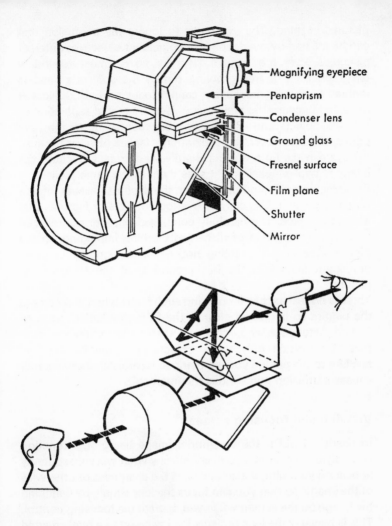

- Magnifying eyepiece
- Pentaprism
- Condenser lens
- Ground glass
- Fresnel surface
- Film plane
- Shutter
- Mirror

How the reflex method works. Image-forming rays pass through the lens on to a viewing screen via the mirror. The eyepiece is focused on the screen image via the pentaprism surfaces.

pictures in mind. The eye tends to ignore the confusion that can be created by overlapping or coincident objects at different distances from the camera. The by now almost legendary telegraph pole or tree growing out of the subject's head is ignored by the eye because it cannot focus on both objects at once and because the brain recognises the spatial separation of the two objects and sees no link between them. In the final print or slide, however, this separation is far less obvious because the eye can see both objects sharply. And, in fact, because the image is two-dimensional, it sees them in the same plane.

Similarly, in your enthusiasm for the pictorial aspect of the scene in general, it is easy to overlook objects or features that are out of place. The carefully composed outdoor portrait can be ruined by an item of discarded clothing impinging on the picture area or a distracting notice-board, signpost or other prominent feature in the background or at the edge of the picture.

There is no real excuse for missing such faults when you can see the picture so large and clear in the SLR viewfinder. You can and must study the whole scene minutely and carefully to ensure that you include only those objects and features that are relevant to the picture you are trying to create. Additional matter causes confusion and divides the interest.

Viewing and focusing screens

In nearly all SLRs, the viewfinder image has a dual function Not only does it allow you to see exactly what will subsequently appear on your film; it also indicates the sharpness or otherwise of the image, so that you can focus the lens simply by watching the image on the screen while you operate the focusing control. This is because the lens projects the image on to a finely matted glass or plastic surface in more or less the same way as a slide projector throws an image on to a screen. As you focus the lens, so the image becomes sharper or less sharp.

The focusing screen is in the top of the camera at right angles to the lens axis and it receives the image via a mirror placed at 45° behind the lens. The distance from the lens to the screen via the mirror is exactly the same as the distance from the lens to the

film in the film plane. Thus, the great advantage of the SLR screen in showing *exactly* the same image as will subsequently appear on the film. It is exactly the same, that is, in regard to the viewpoint, as compared with the slightly different viewpoint of the viewfinder consisting of a separate optical system. It is rarely the same in actual area, because most cameras include a safety margin varying in extent from model to model, so that the viewfinder actually shows marginally less than will appear on the film. You might find this annoying at times, but the margin is generally considered necessary because both slide mounts and the negative carriers of most enlargers encroach slightly on the image area.

A matted screen alone is not now considered sufficient for viewing and focusing, because it cannot give an evenly illuminated image. It tends to give a bright area in the centre, fading off into quite dark corners. The evenness of the illumination can be improved by placing a condenser lens over the screen, but, as the normal condenser is bulky and heavy, the fresnel lens originally developed for lighthouses and similar applications has been adapted to photographic use. These days, it consists of a thin, light sheet of plastic engraved with carefully angled concentric lines which serve to spread the light from the lens evenly over the whole image area.

The fresnel rings are rather prominent in some cameras and there is a danger that they can interfere with focusing, because it is possible to focus an image on a screen with fresnel rings only. The focus is not accurate, however, and you have to be careful to avoid this pitfall. In most cameras, the lines are barely visible and you soon get used to ignoring them.

The matt screen covered by a fresnel lens (sometimes, the screen is in one piece with the matt surface simply etched on the underside of the fresnel lens) should be sufficient to achieve accurate focusing with almost any subject, but it is now nearly always supplemented by further aids. The screen itself cannot be given too finely ground a surface because that would aggravate the tendency toward uneven illumination and would also give rise to interference from the aerial image on which the eye can also focus with the aid of the fresnel rings.

The screen of many SLRs is, therefore, relatively coarse grained,

while for critical focusing a more finely etched 'collar' surrounds a central spot of around 7-12 mm in diameter. This really fine grain surface maintains its brightness by being in the middle of the screen only and is, additionally, free from the fresnel rings that might otherwise interfere with its function.

The central spot is the rangefinder section and is often of the microprism type, containing large numbers of tiny crossed wedges which cause the image to 'shimmer' and, in some cases, give a double-image effect when the lens is incorrectly focused. As you turn the focusing control, the image steadies and becomes sharply defined. When it is completely steady and sharp, the lens is correctly focused.

This type of rangefinder spot is an improvement over the older split-image type which consisted of one pair of crossed wedges forming a discontinuous image across a central, usually horizontal, border. The image becomes continuous when the lens is correctly focused. The main disadvantage of this type of rangefinder is that it is only fully effective with subjects that have vertical or near vertical straight lines or borders between tones which can show up the break across the central division. Nevertheless, it can be faster in use than the microprism type and many cameras now incorporate a central split-image type with a microprism surround.

Even the microprism rangefinder does not solve all problems. Its efficiency depends on its construction and the eyesight of the user. Some models seem never to provide a completely steady image for certain people – generally, wearers of spectacles. In any event, they should never be relied on at small apertures, say less than about $f4$.

The focusing screen is said also to give you an impression of the depth of field, i.e. how much of the picture is sharp and how much is slightly or considerably out of focus. This is true only to a limited extent, because the screen surface tends to sharpen the image a little. Moreover, depth of field depends ultimately on the degree of enlargement of the final image and the viewing distance. Nevertheless, the screen image does generally give a far better overall impression of the type of picture you will obtain than the separate optical system of the non-reflex camera.

Many cameras carry various signals and information details in the viewfinder. Where an exposure meter is built-in, for example, and particularly when the meter is coupled to the shutter and aperture controls, it is convenient to show the necessary needle or pointer in the viewfinder, so that the exposure can be checked without taking the camera away from the eye. Sometimes, the actual aperture and/or shutter speed is visible. In some cameras, a signal appears in the viewfinder when the film is not wound on ready for the next exposure. Many cameras are also using light signals in the viewfinder, most frequently in the form of light-emitting diodes (LEDs). These can indicate under- or over-exposure settings and can replace the meter needle by lights on a scale or a digital readout.

Focusing techniques

The normal method of focusing a single lens reflex is to turn the focusing ring surrounding the lens mount in the direction that makes the picture appear sharper. As you turn the ring, the lens is moved toward or away from the film until the image of the subject on which you are focusing reaches its sharpest and then gradually becomes unsharp again. This is a minor disadvantage of any screen method of focusing, in that you cannot recognise the point of sharpest focus until you have passed it – and, perhaps, repassed it as you turn the focusing ring back again. It is a procedure you soon get used to, however, and focusing is really quite a rapid operation.

It is made more positive and rapid if you always focus with the lens set to full aperture. Then the lens provides least depth of field (see page 38) and it is easier to focus on the main subject. The screen image is also brighter when the lens is set to full aperture, allowing you to see detail that a less bright image might obscure.

This requirement of full aperture viewing and focusing is now taken care of in most lenses by the automatic diaphragm (see page 102). The lens diaphragm providing the aperture adjustment normally remains fully open, closing down only when you press the shutter release.

Whether you use the rangefinder, the fine ground section or the whole screen, there are various techniques of focusing the required image in different circumstances.

Frequently, your subject may have some depth and, as you view the image on the screen, you find that only part of it looks sharp. In a landscape, for example, you may have a tree fairly near the camera, buildings farther away and a line of hills with more trees in the far distance. If you focus on the nearby tree, both the buildings and the hills will probably be rather blurred, or out-of-focus. If you focus on the mid-distance buildings, the tree and the distant hills may be out of focus.

Similarly, when you focus on something at fairly close range, such as a person's face, you may find that the eyes are in sharp focus, while the ear or back of the head are less sharp.

You have to remember that these differences in sharpness are exaggerated by the large lens aperture at which you view and focus and that, as you close the diaphragm, or stop down to a smaller aperture, more of the picture comes into sharp focus. Generally, however, you focus on the most important part of the picture — in a landscape, the part on which the eye is intended to rest; in a portrait, normally the eyes.

Focusing moving subjects

When the subject is moving, focusing can become more difficult. If you are shooting incidents in a football match, you will not find it practicable to follow the game with your camera, refocusing constantly as the action moves from one end of the pitch to the other. In fact, you will normally remain in one position most of the time, perhaps near one of the goals, and it is not really much worth your while trying to shoot action much farther out than the 20-yard area. So you set your focus to cover as much of that area as possible, using your depth of field scale (page 37) to assess the area covered.

This is known as zone focusing, and you can use a similar technique for many subjects. Children playing on the beach, for example, may remain within a predictable area or zone. If you take so-called candid shots in the streets, you can so

Zone focusing. The standard lens **(left)** can provide two or more useful focusing zones according to the setting of the distance scale. A wide-angle lens **(right)** provides a deeper zone at the same aperture.

arrange things that you press the release only when your subject is within the zone that you know you can cover sharply.

Zone focusing is generally used to cover erratic movement. When your subject moves in a predictable direction, like a motor-car along a road or race track, you can use a more precise method. You can see where the car is going and you can pick out an object such as a tree, road sign, telegraph pole, etc, that it has to pass and focus on that. As soon as the car reaches the chosen spot, you release the shutter.

A further technique often used for subjects moving in a predictable direction is to pan the camera. This means that you sight the subject in the viewfinder and, swinging the body from the hips, try to keep the subject 'stationary' in the viewfinder, so that the movement is minimised or cancelled out completely. You release the shutter when the subject reaches the spot on which you have prefocused while continuing the panning movement. The theory is, of course, that a moving subject can be recorded as if it were stationary, if the film moves at the same speed as the subject. The SLR does not provide for the film to move independently of the camera, so we swing the camera in an attempt to match the speed of the subject. It is a useful technique that usually enhances the impression of movement by blurring the background − a stationary subject recorded on a moving film. With perfect technique, even the fastest-moving subject can be recorded at shutter speeds as low as 1/60 sec, but it is generally advisable to use 1/125 sec or faster to avoid the possible effects of an erratic camera shake superimposed on the panning movement.

Focusing in the dark

Focusing in poor light conditions can often raise serious problems. There may be occasions when it is very difficult to see the image at all. If you cannot approach the subject, the only answer is to focus by scale. That means that you estimate the distance between the camera and the subject and set that distance on the focusing scale of the lens. This can obviously lead to errors, because many people find it difficult to estimate

distances accurately and few focusing scales are very finely calibrated. You have to guess not only the distance but also the correct setting of the scale to correspond with that distance. The latter difficulty remains, even if you can approach the subject and measure its distance. In those circumstances, however, you can frequently use a simple focusing aid. You can, for example, place a flashlamp or pocket torch in the subject position, switch it on and focus on that. It is best not to have the beam pointing directly at the camera. Or you can shine such a light on to the subject for focusing purposes. If the subject is a person, you can ask him to strike a match or use a cigarette lighter. Sometimes, it is even sufficient to place a white card or newspaper temporarily in the subject area.

Exposing the
Average
Subject

You can find out how to view and focus the SLR camera simply by holding it to your eye and manipulating the controls. That is the great distinguishing feature of this type of camera. You have a large brilliant image on the screen that moves in and out of focus as you adjust the lens. Before you can actually take a picture, however, you have to learn how to use two other important controls – the shutter speed and the aperture setting which together control the exposure of the film.

Mechanics of exposure

Exposure is the term we use to describe the action of allowing light to fall on the film. This is what makes the picture. The film is, in fact, a plastic base with a coating of gelatine in which grains of a light-sensitive silver compound are dispersed. Light sensitivity in this case means that when the coating (which we call the emulsion) is exposed to light, the silver compound is so affected that subsequent treatment with certain chemicals (development) causes it to be reduced to black metallic silver. Thus, if we take a piece of film, hold it in the light and then develop it, the emulsion turns completely black. If, however, we take the piece of film from its protective packing in darkness and place a small coin on it before exposing it to light, subsequent development of the film, in darkness, produces black emulsion everywhere except in the part covered by the coin. That part remains clear. In other words, any part of the film exposed to light goes dark on development, while any part not exposed remains clear.

It is evident that, instead of simply laying a coin on the film we could project a picture on to it, just as the camra lens does. Then, the light parts of the picture would blacken the emulsion and the dark parts would leave it clear. We would, in fact, obtain a duplicate of our projected picture – but with its tones reversed, which is why we call it a negative.

When we reach this stage, however, we are projecting an image on to the film that probably consists of a variety of tones, some very light, some very dark, and many of intermediate degrees of brightness. The problem is: how long do we allow

the light to act on the film? If we make it too long, most of the tones totally blacken the emulsion, because total blackening needs only a certain amount of light and that can be obtained either from a bright light for a short period or a dim light for a longer period. We have to find the exposure that allows each tone to register correctly – not so long as to turn most of the emulsion black or so short as to have no effect on the emulsion or to affect it only in the brightest areas.

Exposure controls

This ideal exposure will obviously vary with the conditions in which we take the photograph. In bright sunlight, many objects reflect a lot of light. In ordinary domestic lighting, or on a dull day, or in street lighting at night, the same or similar objects are much less brightly illuminated and reflect a great deal less light into the camera lens. So we need a fairly wide range of adjustment on the camera to allow more or less light to reach the film.

We have, in fact, two such controls – the shutter speed, which controls the length of time for which the light is allowed to act on the film, and the aperture or diaphragm opening in the lens which acts as a kind of window to control the intensity of the light reaching the film. It is the combination of these two factors – time and intensity – which make up the exposure.

Controlling the intensity

Let us first consider intensity which, as we have said, is controlled by the aperture. The aperture is just what it says – an opening or hole. It is formed by a diaphragm placed between the lens components and consisting of an iris-like construction of thin metal blades which open from the centre to provide a (usually) more or less circular hole of continuously variable size. The larger we make the hole, the greater the intensity of the light passing through the lens, just as a larger window admits more light to a room.

So that we can calculate the effect of various settings of the aperture, it has a control calibrated in ×2 steps, i.e. at each marked setting it passes twice as much light as at the next smaller setting. Unfortunately for those who like their technicalities to be simple, the actual markings are a little confusing. They run in the series 1, 1.4, 2. 2.8, 4, 5.6, 8, 11, 16, 22, and sometimes further. Actually. each successive figure (allowing for a little rounding off) is the previous figure multiplied by the square root of 2, which is about 1.4. There is a very good reason for this, but we need not go into it too closely except to say that these markings represent light-transmitting power and the same figure represents the same power on each and every lens – not the same size of aperture.

We generally refer to these numbers as f-numbers or stops, saying that we have set the lens to $f8$, $f4$ or whatever. You will not find the full range of numbers on every lens, because the smallest number denotes the greatest light-transmitting ability and a lens with a small first number, say, $f1.2$ or 1.4 ($f1$ is a rarity), is more expensive than one with a slightly larger first f-number (say, $f2.8$ or $f3.5$).

You will notice that the $f1.2$ and $f3.5$ that we have just quoted do not appear in the standard series. It is, in fact, not uncommon for the number denoting the maximum light-transmitting ability of a lens to fall outside the standard range, because it is a selling point. There are many people who would consider a lens engraved $f1.9$ as infinitely superior to one engraved $f2$, although the difference in light transmission would be of no practical value.

So, our first control over the light acting on the film is the aperture or stop, designated by its f-number. The smaller the f-number we set, the greater the intensity of the light reaching the film, because the smaller f-number denotes the larger aperture.

Controlling the time

Now we pass to the control of time – the shutter speed. The shutter serves two main purposes:

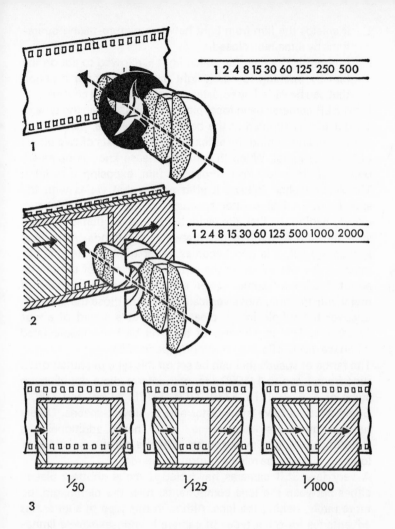

1 2 4 8 15 30 60 125 250 500

1 2 4 8 15 30 60 125 500 1000 2000

$\frac{1}{50}$ $\frac{1}{125}$ $\frac{1}{1000}$

Shutters: 1, Blade shutters have limited top speeds and leave the film exposed when the lens is removed. 2, Focal plane shutters protect the film when the lens is removed. 3, The higher the shutter speed, the narrower the gap between the focal plane shutter blinds.

1 It shields the film from light between picture-taking operations by remaining closed.

2 It controls the time for which light is allowed to act on the film by opening to admit light and closing after a period that can be varied by adjusting the shutter speed control.

Most SLR cameras have focal plane shutters. This is the type of shutter that is situated at the back of the camera, just in front of the film and behind the reflex mirror. It consists of two blinds of fabric or metal. When the shutter release knob is operated, one blind starts to move across the film, exposing it to light. The second blind follows it after a time that varies with the speed set. At fast shutter speeds, the second blind follows closely behind the first, the result being that the film is exposed strip by strip through a gap between the blinds. As slower speeds are set, this gap becomes wider until, on horizontally moving shutters, it equals the whole image area of the film at about 1/30 sec. Some newer shutters, however, usually of metal construction, move vertically, and with those the gap may uncover the whole image area at once at a speed of about 1/100 sec. The significance of this will be better appreciated when we discuss flash photography (page 135).

The range of speeds that can be set on this type of shutter often runs from 1 sec to 1/1000 sec, with intermediate doubling-up steps of $\frac{1}{2}$, $\frac{1}{4}$, $\frac{1}{8}$, 1/15, 1/30, 1/60, 1/125, 1/250 and 1/500. Some shutters have even faster and/or slower speeds. Others have a more restricted range. Most have, additionally, a B setting, which allows you to hold the shutter open for as long as you keep the release button depressed.

A very few SLR cameras have bladed metal shutters placed either between the lens components, near the diaphragm, or, more rarely, behind the lens. Although this type of shutter has advantages for other types of camera it imposes severe limitations on the versatility of the SLR, because the between-lens type means either that each lens has to have its own shutter, with an auxiliary shutter to protect the film, or that lens interchangeability can be effected only by changing the front component of the lens, leaving the rear component and shutter fixed to the camera. That limits the range of lenses available and prevents the use of various behind-the-lens accessories.

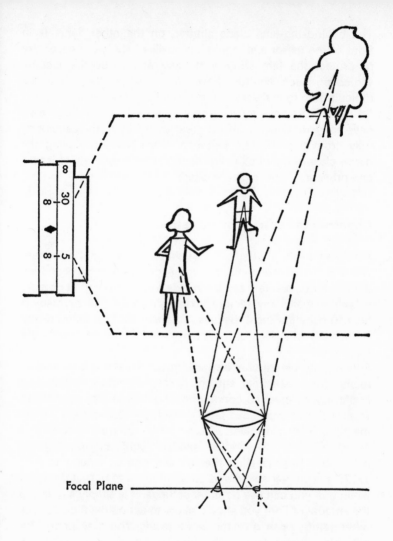

Focal Plane

Depth of field. The central figure is at the focused distance and produces a sharp image. The other figure and the tree are at the limits of the depth of field, producing slightly unsharp images that are adequately sharp at the correct viewing distance.

The behind-the-lens blade shutter, on the other hand, is in front of the mirror and, again, an auxiliary shutter is necessary to protect the film while you view and focus the picture. Moreover, such shutters have to be rather large and are difficult both to make and to incorporate in the camera body.

So most SLRs have focal plane shutters which, although they have some drawbacks, impart great versatility to the camera by fully protecting the film between exposures and leaving the mirror clear of obstruction so that an enormous range of lenses and other accessories can be used.

Choosing the correct combination

These, then – the shutter with its variable speed and the aperture with its variable size – control the exposure. We can combine them in innumerable ways to provide exactly the right exposure to suit virtually any picture-taking situation. The problem is how to combine them, because it is evident that many of the various combinations of settings available provide exactly the same result.

For example, we start out by deciding just what settings we have to use for a particular subject – say, an outdoor portrait in bright, lightly clouded conditions. The easiest way to find out what exposure is needed is to consult the leaflet packed with the film. It always gives recommended aperture and shutter speed settings for various standard subjects and lighting conditions. We may find that for our portrait it recommends 1/125 sec shutter speed and an aperture of f11. That does not mean that you can use no other settings. It is simply a guide to the amount of light you should allow to act on the film. Various other settings can give the same result. You may prefer, for example, always to use the highest possible shutter speed because you are afraid that you might shake the camera and blur the picture slightly at slower speeds. Suppose you decide to use 1/500 sec. That is two steps faster than 1/125 and, as each step halves the exposure time, you have, in fact, reduced it to one-quarter of the recommended time. So, to restore the balance, you can alter the aperture setting to increase the

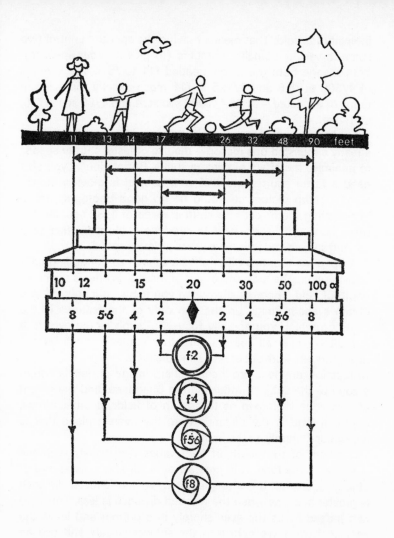

Depth of field scale. Aperture numbers either side of the focusing index are opposite figures on the distance scale indicating the near and far limits of the depth of field.

intensity fourfold. That means moving the aperture control two steps toward the smaller numbers (to give a *larger* aperture). You change from the recommended f11 to f5.6. The settings of 1/500 at f5.6 and 1/125 at f11 mean exactly the same in terms of exposure – as do 1/1000 sec at f4 and 1/60 sec at f16, and so on.

Why do we have this exceptional range of control? We have already suggested one reason – the use of faster shutter speeds to minimise the effect of camera shake. But obviously you also need a faster shutter speed if your subject is moving. If you want a sharp picture, it would be no good photographing a fast-moving motor-car at a shutter speed of 1/30 sec. On the other hand, you may *want* to produce a blurred effect of a moving subject and thus have to use a slower speed.

The aperture, too, has other effects as well as controlling light transmission. The most important of these side effects concerns depth of field. Theoretically, when you focus your subject, you obtain a sharp image on the film only of the features in the plane on which you actually focused – such as the eyes in a portrait – while all features in other planes – such as the nose, ears, etc – are out of focus and unsharp.

In practice, any lens produces a sharp image of details within a zone of the subject rather than in one plane, and the extent of that zone is known as the depth of field. In other words, depth of field is the distance from the nearest plane that is reproduced sharply, to the farthest.

The extent of the depth of field varies enormously with the aperture of the lens. It is greatest at small apertures and least at large apertures. It is also greater when the focused distance is greater and less when the focused distance is less. Thus, we can indeed focus the eyes sharply in a portrait and leave the ears unsharp if we approach the subject closely and use an aperture of f2 or larger. Alternatively, we can obtain a sharp image of everything in a landscape from the nearby farm gate to the line of hills in the far distance – if we focus on something about 7–10 m away and use an aperture of about f11 or smaller.

So, when we choose the aperture and shutter speed that will give the correct exposure, we have to think not only of admitting

the correct amount of light to the film, but also of such questions as how much depth of field we require, how much movement there is in the subject, and whether the necessary shutter speed calls for a tripod or other support to steady the camera.

Electronic shutters

In most SLRs, exposure calculations are performed for you by a simple exposure meter linked to aperture, shutter speed and film speed controls or by complicated electronic circuitry. The latter type generally require an electronically-timed shutter. Such shutters have been available for many years and were fitted to a few short-life camera models. There was no point in them until further developments in integrated circuitry brought electronics into general use in cameras.

Now we have incredibly sophisticated models that control the exposure duration while it is going on. You set the aperture and the meter circuit reads through the lens and switches the shutter off at the end of the required exposure time. (You still have to press the button!) On some models, you set the shutter speed and the circuitry sets the aperture. Or you can have the choice of either mode and several others, too, such as auto flash, stopped down or full aperture, etc.

Films and
Film Speed

There is quite a selection of films available for use in your 35 mm SLR and a variety of packings in which you can purchase them. Basically, there are three main types:

1 Black-and-white, on which you obtain a negative from which black-and-white prints are made.

2 Colour negative or colour print film, which also provides a negative, but with colour included, so that colour prints can be made.

3 Colour transparency or colour slide film, which is a one-stage film only, providing a positive colour image on transparent film that can be viewed directly in various types of viewer or projected on a screen.

The use of colour film is increasing all the time, particularly with that part of the general public that exposes perhaps a few rolls of film a year, but black-and-white film is far from obsolete or even obsolescent.

Those who process and print their own pictures, for example, work for the most part in black-and-white, largely no doubt because colour printing is expensive, complicated and time-consuming. The production of colour transparencies is easier and less expensive, but does not give the processor much scope for individual treatment of his pictures.

There are various makes of black-and-white film and each user has his favourite brand. There is, however, very little to choose between the reputable makes and there is no point in discussing their particular attributes. They are all reliable, but undoubtedly there are slight differences from brand to brand, and it is wise to settle as quickly as possible on one brand and stick to it. You learn by experience how that particular film reacts to given circumstances and processing, and can handle it with confidence.

The meaning of film speed

The choice you *do* have to give some thought to concerns film speed. Each film has a given sensitivity to light, some being more sensitive than others, so that they can be used in poor light conditions or when very brief exposure times are necessary.

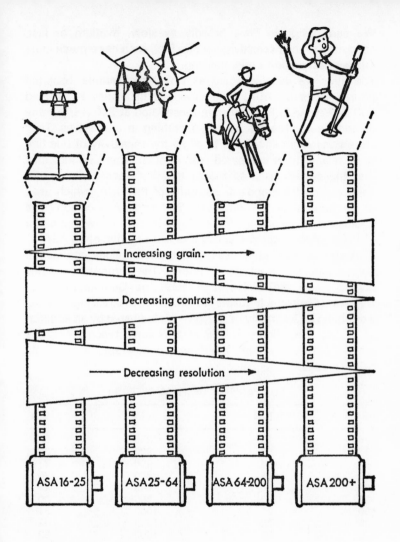

Increasing grain.

Decreasing contrast

Decreasing resolution

ASA 16-25 ASA 25-64 ASA 64-200 ASA 200+

Film speed, grain, resolution. Generally speaking, the slower film gives fine grain, high contrast results. The faster film may show more grain and have less contrast. In modern emulsions, the differences between emulsions are significant only at extremes of speed.

We can designate films broadly as slow, medium or fast, according to their sensitivity; but, in fact, each has a much more precise designation on its packing.

The films we usually regard as slow, for example, bear the figures 40 or 50 ASA. Medium-speed films may be marked 100 or 125 ASA. Fast films are those rated at 320 ASA or any greater figure. The figures mean nothing in themselves. They are a convenient shorthand to allow the sensitivity of one film to be related to or compared with another. The ASA indicates that the system used to assess the film's sensitivity is that approved by the standards authority of the USA, which used to be known as the American Standards Association. The figures are on an arithmetical scale so that we know that a film of 100 ASA, for example, is twice as fast as a film of 50 ASA.

ASA speeds are widely used in countries outside continental Europe and the Soviet bloc countries. The European countries generally use the DIN system, from the German industrial standard (Deutsche Industrie Norm). This system is logarithmic, a doubling of sensitivity or speed being indicated by an addition of 3 to the speed figure. Thus, a 30 DIN film is twice as fast as a 27 DIN film. The systems are directly comparable, as the table below shows.

COMPARISON OF FILM SPEEDS

ASA	DIN	ASA	DIN
25	15	250	25
32	16	320	26
40	17	400	27
50	18	500	28
64	19	640	29
80	20	800	30
100	21	1000	31
125	22	1250	32
160	23	1600	33
200	24		

We use these speed figures as a basis for exposure calculations. The faster film needs less light to achieve the same amount of blackening as the slower film exposed to more light. If the recommended exposure, for example, for a 125 ASA film in given circumstances is 1/500 sec at f4, the 250 ASA film needs

only 1/1000 sec at *f*4 or its equivalent to produce the same density in the image.

Choosing the film speed

The choice of a film by its speed depends on various factors. Now that we have reasonably priced fast lenses for 35 mm cameras, there is very little call for ultra-fast films of more than 400 ASA and most such films have been discontinued. They were never for general use, in any case, because in sunlight they demanded small lens apertures that frequently gave much more depth of field than the photographer required.

The very fast film has other disadvantages. It achieves its extra speed from the incorporation in its emulsion of relatively larger grains of silver halide (the light sensitive component of the film) and these larger grains tend to overlap each other at their various depths in the emulsion and so become visible as 'clumps' in the enlarged print. This can prevent the reproduction of fine details and also cause an unpleasant 'graininess' in the image.

A further characteristic of the faster film is that it generally gives lower contrast than slower films and that, too, can sometimes make the picture look less sharp.

On the other hand, the very slow film – say, of 40 ASA or less – rarely shows graininess, even at very great degrees of enlargement, and has much higher contrast. This higher contrast can be a drawback, because it sometimes becomes unmanageable and it makes the film less tolerant of exposure and processing errors. It has, in the jargon, less latitude.

The slow film is not now used very often because of the great improvements in emulsion manufacture in the past ten years or so. The medium-speed film of 100–125 ASA can give virtually grain-free results at degrees of enlargement sufficient for most purposes, and has, additionally, a reserve of speed that allows it to be used in most lighting conditions. Even the 400 ASA film rarely shows objectionable graininess, but it is frequently too fast for bright light conditions and is only used regularly by those who expect to shoot a lot of film in poor light.

For the majority of people, the medium-speed film is the obvious choice. It can tackle almost any subject in almost any conditions. The fast film is for the special job or for the photographer who feels that he must always have that extra speed available – just in case. The press photographer is the obvious example. The slow film is, again, for special jobs such as fine detail copying, photomicrography and, perhaps, for use in very bright lighting when larger apertures or longer shutter speeds are required fo₁ a particular purpose.

Film packings

Black-and-white film for 35 mm cameras is sold in various packings. The commonly used packages are the loaded cassettes giving either 36 or 20 exposures. The cassette is a small meta¹ or plastic canister with a felt-lined slit through which the film can pass without admitting light to the film remaining inside. The film in the cassette is on a spool that protrudes through a hole at one end of the cassette, again forming a light trap, and with a bar to engage the rewind mechanism of the camera through another light-trapped hole at the other end. One or both ends of the cassette can be removed to extract the spool of film for processing and for reloading with fresh film.

The cassettes in which the film is supplied by the manufacturer are generally said to be for one-time use only and they are, in fact, retained by most processing stations to whom you send films. They can, however, with reasonable care, be reused frequently. You should be careful not to dent or otherwise damage them and to keep the felt or velvet-lined slit free from dust or other impurities that might scratch or otherwise damage the film.

Special reloadable cassettes are also available, some for particular cameras and some for universal use.

If you do retain your cassettes for reloading, you can buy film rather more cheaply as ready-cut and trimmed refills of 36 or 20 exposures or in bulk lengths of 5 or 17 metres. To load a cassette with a refill, you simply prise off one end of the cassette (some reloadable types screw off), extract the spool and remove the

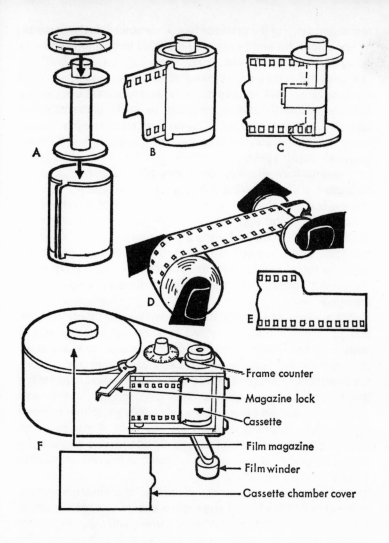

Loading cassettes: **a,** Parts of cassette. **b,** Loaded cassette. **c,** Method of attaching film to cassette spool. **d,** Winding film on to spool. **e,** Trimmed leader. **f,** Daylight loader.

remaining piece of the previous film. Then you place the cassette, its spool and the end or cap you removed in positions you can easily reach in a darkroom or changing bag, together with the still wrapped reload and a piece of adhesive tape (preferably masking tape). Making sure that *all* light is excluded, unwrap the film and secure its end to the spool by sticking the adhesive tape to the 'glossy' side of it, laying the end of the film on the spool core (emulsion towards the core) and passing the tape round so that it sticks to the spool and then to the film again on the emulsion side. You can easily tell which side is which because the film is always wrapped emulsion side in.

Having fastened the end of the film to the spool, you hold the spool in one hand and the film in the other, being careful to touch only its edges, and wind the film on the spool. Keep the film fairly taut while you wind, but do not pull on it so that its coils slip round and rub over each other. If you do, you may get marks and scratches on the film that show up badly on the enlarged print.

Refills are supplied already trimmed, with a short tongue at one end to fit into the slot provided in some cassette spools and with a long tongue on one side of the film that was originally designed for the bottom-loading Leica camera. In many cases, the short tongue is superfluous and the tape method of attaching the tongue is more reliable. The long tongue is still only essential for certain Leica cameras, as nearly all 35 mm cameras now load by opening or removing the back. Some cameras, however, have slotted take-up spools that require a small trim the width of the long tongue to be made at the end of the film. Others need no trim at all.

The bulk lengths of film are, naturally, supplied untrimmed, and you cut off the length you require and trim its ends yourself, according to the demands of your camera and your method of loading. If you intend to reload your cassettes from bulk film regularly, particularly the 17 m length, it is best to buy a bulk loader which enables you to load cassettes in daylight once you have placed the roll of film in the light-tight magazine compartment of the loader. Otherwise, you have to devise some method of cutting the required length from the roll in darkness, returning the roll to its package and, still in darkness, load the

cassette. It is a fiddling and time-consuming business and the film may suffer marks and scratches from the handling involved. The advantage of using bulk film, apart from expense, is that you can load any number of exposures you require up to the maximum 36. If you have a particular job to do that needs no more than half a dozen or a dozen exposures, you can load a cassette with just the right number. The lengths required for various numbers of exposures are given in the table below.

LENGTH OF FILM REQUIRED FOR ANY NUMBER OF EXPOSURES

Number of Exposures	Length of Film Required		Number of Exposures	Length of Film Required		Number of Exposures	Length of Film Required	
	in.	cm.		in.	cm.		in.	cm.
1	11¾	30	14	31¾	80	27	51	130
2	13⅛	34	15	33	84	28	52½	133
3	15	38	16	34½	88	29	54	137
4	16¼	41	17	36¼	92	30	55½	141
5	17¾	45	18	37¾	96	31	57	145
6	19¼	49	19	39¼	100	32	58½	148
7	20¾	53	20	40½	103	33	60	152
8	22	56	21	42	107	34	61½	156
9	23¾	60	22	43¾	111	35	63	160
10	25¼	64	23	45	114	36	64½	164
11	26¾	68	24	46½	118	37	66	167
12	28½	72	25	48	122	38	67½	171
13	30	76	26	49½	126	Including trimming		

Colour film for 35 mm cameras is supplied in the same type of cassette as black-and-white film and, again, is generally available in 20 and 36 exposure lengths. Occasionally, 12-exposure lengths may be available, but, as you pay for the cassette each time, the shorter the length of film you buy the greater the cost per exposure.

Reloads are not generally available and colour film in bulk lengths is difficult to obtain regularly.

Choosing colour film

The speed choice with colour film is now similar to that for black-and-white. There are 400 ASA versions of both negative and slide films, while the popular speed is still in the mid-range

of 100-200 ASA. There remains, however, the exceptional Kodachrome 25, of 25 ASA, and a 64 ASA version. It is common practice to uprate colour film, i.e. to rate, say, a 400 ASA film at 800 ASA or faster. Most processing laboratories offer the required modified treatment. Uprating colour films is said to retain colour density. It is not necessary with black-and-white, where excellent prints can be made from relatively thin negatives.

The choice is, of course, an individual matter, but at the present state of development it is probably true to say that the slide films rated at more than 200 ASA are better regarded as specialist types for use when the circumstances really demand that extra speed. Such circumstances are, in fact, comparatively rare, because, in low light conditions, colours are to some extent distorted and the higher speed does not give better colour rendering. Its main asset is that it enables you to shoot moving subjects in poor light, but with today's fast lenses that can often be accomplished quite satisfactorily with the slower films.

Apart from speed, your choice of colour film is based on the type of colour rendering it gives and whether you wish to be able to process it yourself. All colour print films can be processed by the user and the process is not too difficult. It is rather more difficult, however, to judge what kind of result you have produced because a colour negative looks very strange to the untrained eye. First, its densities are, as you would expect, negative. The film has a denser image in the bright parts of the subject and little or no density in the shadows. Additionally, however, the colours appear as complementary to the original colours. A blue sky looks yellow, a red dress looks green-blue (cyan) and grass looks red-blue (magenta). These are the dyes used in colour films to produce, by what is known as a subtractive process, the final natural colour result. Cyan subtracted from a white-light beam gives red, magenta gives green, and yellow gives blue.

The appearance of nearly all colour negative films is further complicated by the fact that a yellow or orange dye is incorporated at the manufacturing stage and remains visible after processing. Its function is to improve the clarity of the colours in the final print, but it is of sufficient density in the negative to obscure some of the weaker colours completely.

All the better-known colour slide films except Kodachrome can be processed by the user and official kits of chemicals are supplied by the manufacturer. Alternatively, the manufacturer, his agent, or an independent processing laboratory can undertake the processing for you. Home processing of colour slide films is not difficult, and it is now a lot less laborious than it used to be. Unless a lot of such work is undertaken, however, it can be expensive.

The value of home processing lies in the fact that you can interfere with the accepted mechanics to produce unusual results. This, of course, takes even more time. It also calls for carefully controlled and fully annotated work if you want to be able to reproduce a particular effect. Even then, the results are often unpredictable, but sometimes very rewarding.

Uses of colour negative film

Colour films are reasonably versatile, and some workers prefer to use colour negative film for all their photography because it can with comparative ease be made to produce not only the colour prints for which it is designed, but also colour slides and black-and-white prints. This is because a colour negative film is essentially an intermediate stage, just like the black-and-white negative.

As its tones are reversed, it can be used in almost exactly the same way as a normal negative to provide black-and-white prints. Its colours interfere with the process, to some extent – particularly the colour mask, because it is not far in colour from that of the ordinary darkroom safelight. Thus, the colour negative needs more exposure than the normal black-and-white negative to produce a print on bromide paper. Moreover, as its image is composed entirely of coloured dyes and the bromide paper is sensitive only to a limited range of colours, there is inevitably some falsification of tones. Parts of the image with colours toward the blue end of the spectrum have more effect on the paper than those toward the red end. Grass and foliage (represented by magenta in the negative) may print rather lighter than normal, while red lips, ruddy complexions, etc,

may print darker because they are represented by cyan, which is the blue-green to which the paper is most sensitive.

The difficulty can be overcome by using a special panchromatic paper, but that has the disadvantage that it must be handled in total darkness, because it is sensitive to light of all colours. Generally, however, the straight print from a colour negative is much less obviously tonally distorted than might be expected and most people will accept it without question. Perhaps its major disadvantage by comparison with a print from a black-and-white negative is that it never seems to be really sharp when printed through the average enlarger lens. This is, no doubt, partly due to the presence of three separate layers in the emulsion and partially to the less stringent correction of chromatic aberrations in the lens.

As it is designed to produce a positive colour image on paper, it is evident that the colour negative can do the same thing on film and thus provide a colour slide. Indeed, perfectly good colour slides can be produced in this way – but not on the normal colour slide material, which is specifically designed for reversal processing to give a positive image from a positive, such as the original scene. Nor can you print on to another colour negative film because nearly all colour negatives incorporate a masking dye that remains in the film after processing. You could, theoretically, use an unmasked colour negative to obtain a positive image from a negative, but the colours would not normally be acceptable and the contrast would probably be rather high.

Colour slides are made from colour negatives on a print film specially designed for the purpose. This is not easily obtainable and needs special handling, so that where this service is only occasionally needed it is better to leave the job to a commercial processing laboratory.

Uses of colour slide film

Colour slide film is specifically designed to provide a positive image in full colour on the film used in the camera. There is no negative stage. Nevertheless, black-and-white prints can be

made from colour slides via an internegative – a black-and-white negative made from the slide. Again, you can do this yourself, but if you need only the occasional print it is better to leave it to the specialist.

It has also always been possible to make colour prints from colourslides, but it was rather beyond the capabilities of the amateur until reversal print material became generally available. On such material the print is processed in much the same manner as the film itself. The later arrival of Cibachrome, a dye-destruction process that also produces prints direct from slides, i.e. without an internegative, made things easier for the amateur. But both these direct-positive colour materials are expensive and are impractical for those who need only the occasional print from their slides.

Special film types

Apart from the orthodox black-and-white and colour films previously described, there are a few other materials available for use in the 35 mm camera.

Direct reversal film. A slow black-and-white film, designed specifically for reversal processing to give black-and-white slides, is available in standard cassettes. It is a relatively high contrast material that is better suited to the reproduction of drawings and other line subjects. Nevertheless, it can give good half-tone slides with the extra density required for projection. The film is usually sold with the processing charge included in the price.

Infra-red film. This is a special film that has a much greater sensitivity to infra-red rays than ordinary film. It is also sensitive to visible light and, if its infra-red sensitivity alone is to be used, a filter has to be placed over the lens or light source or infra-red 'illumination' has to be used. Infra-red film has many specialised applications in science and medicine, but its main appeal to the amateur is its ability to photograph by 'invisible' light. This is generally effected by placing a suitable filter or filter bag over a flash unit (bulb or electronic). The true infra-red filter emits almost no visible light and can indeed be used unobtrusively.

Even a deep red filter (which lets some visible light through and thus increases the effective speed of the film) allows a flashgun to be used without attracting too much attention.

Notable characteristics of infra-red film used in daylight conditions are its tendency to reproduce most grass, deciduous foliage and other living greenery in very light tones plus the normal characteristics of red filters — heavily darkening blues and greens and making colours toward the red end of the spectrum appear very light in tone. Additionally, it has considerable mist and haze penetration ability. Naturally, all these characteristics depend on the use of infra-red or red filters. if no filter is used, the infra-red properties of the film are obscured almost entirely by the action of the visible light.

Colour film is also available with extra infra-red sensitivity. This, however, is a very special type of emulsion which is deliberately designed to give false colours. It is not easily obtainable and its uses are limited.

Positive film. A very slow black-and-white film with an emulsion rather like that on the bromide paper used for making prints is provided by various manufacturers. Its popular name is a little confusing in that it is not a material giving a positive image in the way that the direct reversal or colour slide film does. It is not, in fact, a camera material at all, but is intended to be printed on from a negative. It has an extremely fine-grained contrasty emulsion particularly suitable for making transparencies of plans, maps, drawings, printed matter, etc.

This film is commonly supplied in both 35 mm and sheet film and, in the latter form, is useful for making impressively large black-and-white transparencies for display. It can also be used for the various intermediate stages in bas relief, tone line, solarisation and other 'derived' applications.

The Shooting
Operation

We have now run through the most important aspects of SLR photography from the handling point of view — camera construction and controls, viewing and focusing, exposure, the films to use and the meaning of film speed. This chapter puts them all together to give the full sequence of loading the camera, composing and focusing the picture, setting the controls according to nature of the subject and the exposure required, shooting and, finally, unloading ready to start all over again.

Loading the camera

Most SLRs load in more or less the same way. First, you open the back of the camera. This may be by fully pulling up the rewind knob, sliding a catch on one end of the camera, turning a key in the baseplate or some similar operation. Sometimes, the back hinges, sometimes it is completely detached and sometimes it is removed complete with the bottom of the camera.

With the back removed, you see an empty chamber at one end, beneath the rewind knob, and a spool (the take-up spool) at the other under the transport lever. You place the cassette of film in the empty chamber with the protruding knob of the spool toward the bottom of the camera and the cassette mouth with its film leader pointing toward the take-up spool. Pull out sufficient film to pass across the back of the camera and to attach to the take-up spool. Methods vary here, too. The film leader may be slotted into the spool or into a collar passing round it or may be simply laid across the spool under a small clamp to be caught by a wire loop, as in the Praktica range of cameras. Various other quick-load devices are also used. In all cases, however, it is advisable to make sure that the perforations on both edges of the film are engaged by the sprocket wheels that aid film transport before closing the camera back.

With the camera back securely closed, operate the film transport lever once and then turn the rewind knob or crank in the rewind direction to take up any slack in the cassette. Press the shutter release and operate the film transport lever again,

A high viewpoint and a slow shutter speed separate the dancers and emphasise the motion. This is an effective treatment for folk and costume dancers, where the clothing is often voluminous and can create interesting shapes and patterns – *Bogdanovic Miodrag.*

Opposite: Strong side-top lighting, a plain background and some judicious burning-in when printing have produced a simple, uncluttered picture with interest centred on the rim-lit whiskers and gaping jaws – *Harry Paland.*

Feeding time at the zoo produces pictures every day. The trick is to wait for exactly the right moment to release the shutter – *T. H. Williams.*

Page 60: Minimal exposure and strong overdevelopment brings up the sunlit foreground and subdues the background by emphasising the distant haze. Depending on circumstances, a light blue filter can also lower the sky contrast and increase the haze effect – *Harry Paland.*

watching the rewind knob. In most models, it revolves as the film is drawn out of the cassette, affording a check that the transport mechanism is functioning correctly. Press the release and wind on again.

These two 'blind' exposures are necessary to wind off the film that has been exposed to light during the loading operation. The third frame is unexposed film ready for the first exposure. The exposure counter of most modern cameras shows the start mark or No 1 at this stage. The counter returns automatically to the zero position (two steps before the start mark) when the camera back is open. If your exposure counter is not automatic, remember to set it at this stage.

The next step is for cameras with built-in exposure meters (see page 70). These have to be adjusted to the speed of the film in use, which is usually set simply by turning a calibrated disc or wheel until the appropriate ASA or DIN figure is indicated.

Taking the picture

Now the camera is ready for picture taking. The procedure here is to sight the subject in the viewfinder, focus, set aperture and shutter speed according to film speed, lighting and subject, check framing and focus, and release the shutter. We have dealt with the basic aspects of these operations already. Now we can run through the normal practice.

Your standard lens will probably have an automatic diaphragm (see page 100), which means that it remains at full aperture at all times except during the time that the shutter is open. When using non-automatic lenses, it is generally wise to open up to full aperture for all focusing and viewing operations. This gives you the brightest possible picture on the screen and reduces the depth of field (see page 38) provided by the lens so that focusing is more positive.

Your SLR viewfinder gives a large, brilliant image, and you should cultivate the habit of using this advantage to the full. Study the whole picture carefully to ensure that you include only what you want to appear in the final picture and that there are no distracting 'chopped-off' objects at the edges. Make

sure that the main subject is not lost in the background, that background objects are not intrusively placed in relation to the main subject, that the viewpoint is the right one and could not be improved by a slight movement to left or right or even by bringing the camera down to ground level or thereabouts. Check, too, that you are holding the camera straight so that vertical lines are parallel with the sides of the viewfinder and horizontal lines with the top and bottom. Leaning buildings and sloping horizons mean that you have to lose some of the picture in printing, in order to straighten them. That may mean cutting into a vital part of the image and so ruining the picture. In colour slides, such tilts cannot normally be corrected and the picture may well be useless.

Finally, make sure that you have focused correctly and that the image is sharp in the main plane of interest and, perhaps, sufficiently unsharp where you wish to obscure fussy detail. To check that, you have to close the lens down to the shooting aperture. Most automatic lenses provide for this momentary closing down. With some TTL cameras (see page 70), the action of switching on the meter has the additional effect of stopping down the lens.

When you are sure that you have the picture perfectly set up, determine the exposure required by whatever method you are using. This may be by the film manufacturer's recommendation, an exposure meter reading (see page 73), by 'guesstimation' based on experience or rule of thumb (see page 36), or, when you use flash, by the guide number of the flashbulb or electronic unit (see page 159). With the exposure level determined, choose the aperture and shutter speed most suited to the subject, the lighting conditions and the result required, as described on pages 36 and 78.

Holding the camera

You are now ready to press the button — almost. One very important point remains. You must be sure that you are holding the camera correctly. The 35 mm camera is relatively small and light. It is quite easy to move it by the mere action of pressing

Loading the camera: 1, Open camera back. 2, Insert loaded cassette. 3, Attach film leader to take-up spool. 4, Wind on until perforations engage. 5, Close camera back. 6, Make two blind exposures. 7, Set film counter if necessary.

63

the release button. But the essence of orthodox photography is that the film on which the image is being formed must remain absolutely stationary throughout the exposure time. You can appreciate that if the camera moves even a fraction of a millimeter in this time, every point in the image is spread over a larger area and becomes unsharp. Modern lenses and film are capable of forming incredibly sharp images that can be enlarged almost indefinitely without loss of quality. The enlargement from the really good lens loses its definition on enlargement, in fact, from the break-up of the image into the granular structure caused by the composition of the emulsion rather than from its own lack of resolution. It is ridiculous to impair this superb performance by shaking the camera at the moment of release.

Nevertheless, you must not be so frightened of the dangers of camera shake that you hold the camera in a vice-like grip and suspend your breathing while taking a picture. That is more likely to cause camera shake by tremors from tautened muscles. Your grip should be firm but relaxed and your breathing easy and natural. Your body weight should be evenly distributed over both legs, which should be placed only slightly apart. The release button should be squeezed rather than jabbed.

If the lens on the camera is heavy and there is any tendency for the camera to tilt forward, it is advisable to place the left hand in front of the camera and use the thumb and forefinger as a prop into which the lens fits. This gives a steadying hold and allows you to operate the focusing and aperture controls with the minimum of hand movement. This form of grip is essential with long focus lenses, often with the modification of extending the fingers so that the lens barrel lies more or less along the palm of the hand.

The idea should always be that the whole job of supporting the camera is carried out by the left hand, leaving the right hand to exert a steadying influence only. Thus, when you release the shutter, you are in no way relaxing the grip of the right hand and encouraging it to move the camera.

The effect of camera shake is far greater than many people realise and, although it is quite possible to obtain perfectly good results in certain circumstances at speeds of 1/30 sec and slower, it is also possible to obtain, without trying, a distinct

Holding the camera. The camera must be held perfectly still for the exposure. These are the recommended methods. Take advantage of any additional support available. Note the position of the carrying strap.

camera shake effect at 1/1000 sec. *Always* make use of additional support if it is available — by leaning against a solid structure, propping the elbows on a wall, chairback or other object or, of course, in suitable circumstances, using a tripod.

Camera supports

For first-class results with really long-focus lenses — in most cases anything over 135 mm — a tripod is essential. This can easily be appreciated if you simply hold the camera to your eye and watch the viewfinder image of a distant object. You have an exceptionally steady hold if you cannot see some slight tremor in the image. With really long lenses, the image moves appreciably and it is obviously a matter of luck if you manage to get a really sharp image.

Nevertheless, a tripod is not always practicable, and sometimes not even permissible, and you have to risk hand-held shots. The only answer then is to adopt the long-focus hold already described and to make use of any additional support available. Use the fastest shutter speed conditions will allow and release the shutter as smoothly and as carefully as possible.

If you do use a tripod, it must be of really rigid construction. Some long-focus lenses are extremely heavy and are mounted directly on the tripod, the camera being almost an accessory suspended on the back of the lens. The extremely lightweight tripod is worse than useless in such conditions, particularly if there is even a mild breeze blowing. You can see the viewfinder image trembling as the bulky lens catches the wind and the springy tripod legs vibrate under the strain.

A small tripod, as used for table-top photography, is nevertheless permissible. It can be stood on a wall, car bonnet or roof, etc. The short, one-piece legs are usually sufficiently rigid to hold the camera rock steady.

Always use a cable release with tripod shots, preferably at least 10 in long so that you can allow it to fall slack from the lens mounting. If you hold it taut (as many do because they are afraid a bend may impair its efficiency) you will simply transmit your finger movement indirectly to the release button, invalidating the whole concept.

Shortening the ritual

This rather long description of what is involved in preparing to take a photograph may make you wonder whether you can shoot anything but an immovable object. After all, if you go through all this rigmarole every time, your subject will probably have left the country by the time you get round to pressing the button. But, of course, you do not have to go through it all for every shot and, even when most of it is necessary, the procedure soon becomes so habitual that you can carry it out without a great deal of conscious thought.

When taking several shots of a moving subject, for example, you will rarely attempt to refocus for every shot. Provided the subject is not too close to the camera, you have reasonable depth of field to cover a certain amount of movement, even at relatively large apertures and with moderately long-focus lenses. If, however, you use really long-focus lenses, your focusing is too critical and it is not an easy task to shoot subjects moving toward or away from the camera.

Random movement at closer range can usually be handled by the technique of zone focusing, just as predictable movement is dealt with by pre-focusing for a single shot on a point the subject has to pass (page 26).

Watch the film counter

All 35 mm SLRs have a counting device of some kind that tells you how many pictures you have taken. On some older models, you have to set the counter before you make your first exposure. Most modern cameras have an automatic zeroing arrangement which returns the counter to zero when you open the camera back.

It is advisable to watch the counter carefully, so that you always know how many shots you have left. There can be occasions when it is better to sacrifice the last few shots and reload the camera during a lull in the action, rather than to risk running out of film when a vital shot might be missed. Moreover, if you rely solely on the added resistance to winding-on to tell

you when you reach the end of a film, the day will surely come when you will operate the lever too ham-fistedly and tear the film right out of the cassette. Then you cannot reload without taking the camera into a darkroom (real or improvised) or using a changing bag.

The changing bag is an accessory that too few photographers make use of. It is simply a light-tight bag with a light-trapped opening for inserting camera, film, developing tank or what-have-you, and sleeve openings with elasticated ends through which the hands and arms are inserted. All operations can then be carried out by touch, even in broad daylight – with the added advantage that, provided you put everything in the bag before you start, you cannot lose anything by knocking it on the floor.

Unloading procedures

Unloading the camera is a simple operation with all 35 mm SLRs. Almost all models have a small rewind button, either on the camera top plate or base plate. When you depress this button, the sprocket drive is disconnected so that the sprocket wheels and their spindle can turn backward. You then simply turn the rewind knob above the film cassette in the direction indicated to wind the film back on to the cassette spool. The knob generally has a fold-out crank to make rewinding easier. With some older cameras, you may have to hold the button in the depressed position while rewinding.

When you remove the exposed film from the camera it is good practice to mark it in some way to indicate that it *is* exposed. There are innumerable methods. Some wind the leader completely into the cassette so that there can be no mistake. Others, particularly those who use cassettes repeatedly, prefer to leave the film protruding to form part of the light-trap. A simple method is to tear the leader off in a particular fashion. The method used is not important, but it *is* important that you devise some means of avoiding the risk of reloading that film into the camera and obtaining a whole series of double exposures.

Using
Exposure
Meters

So far, we have touched only briefly on the problem of setting the camera controls to obtain the correct exposure. We have seen that each film needs to be affected by a certain amount of light to form a usable image and that the amount of light used is composed of two factors – time (shutter speed) and intensity (aperture setting). We have seen, too, that both shutter speed and aperture have other functions – in relation, for example, to subject or camera movement and depth of field (page 38). We have noted that the instructions packed with the film give basic guidance on the settings required for normal subjects in a range of lighting conditions.

For the photographer who takes more than the occasional holiday snapshot or family portrait, there are many occasions when he needs more precise guidance than is given in the manufacturer's leaflet. This guidance is provided by the exposure meter, as it is popularly known – although light meter would be a more accurate term. The exposure meter is a very simple instrument that contains a light sensitive element connected to a galvanometer in such a way that the intensity of the light falling on the light sensitive 'cell' can be indicated by the movement of a pointer or needle.

TTL exposure meters

Many 35 mm SLR cameras now contain an exposure meter within the camera body with the light sensitive element placed in the light beam behind the lens (or in such a position that light can be deflected to it). The meter readout is visible in the viewfinder and is directly linked to the shutter speed and/or aperture control and the film speed setting. Its link to the light sensitive element is interrupted by the aperture, which controls the amount of light allowed to reach it.

Thus, the meter can control a readout in the viewfinder to indicate the camera settings necessary for correct exposure, and various automatic or semi-automatic couplings can be built in. It is evident that this can be a particularly accurate method of calculating exposure, because the meter is never affected by light from outside the subject area, whether wide-

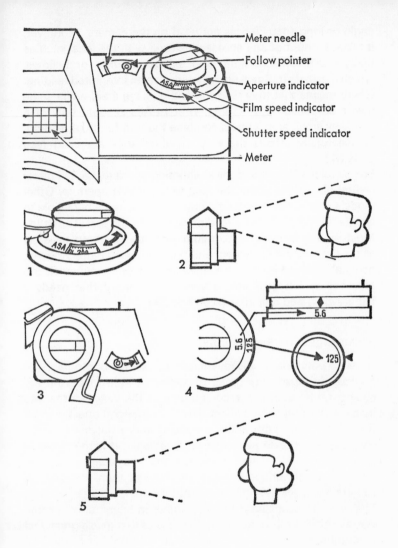

Features and operation of non-coupled exposure meters: 1, Set film speed. 2, Point camera at subject. 3, Adjust meter controls to bring needles into coincidence. 4, Set indicated shutter speed and aperture on camera. 5, Check composition and focus; shoot.

angle or long-focus lenses are used on the camera. Moreover, it takes account of any accessories used with the lens, such as filters, which absorb light, and extension tubes or bellows, which dissipate it. Some such meters give an integrated reading, which means that they read the entire image area, while some give a so-called spot reading, which takes account only of a relatively small area. Others combine the two forms of reading. This naturally affects the way in which they are used (see page 81).

The simpler TTL meter reads at shooting aperture, i.e. the meter switch also stops down the lens to the preset aperture. Other models read at full aperture but have a lens-camera link to enable the meter to give a reading correct for the preset aperture. Most models use either cadmium sulphide (a photo-resistor) as the light sensitive element and therefore need battery power, generally derived from a small mercury cell, or the newer silicon blue cell which generates a very small current that needs a battery-powered amplifier (see page 234).

Advantages of separate instrument

A more important disadvantage to some photographers, particularly those who prefer to meter the light falling on the subject rather than that reflected by it, is the very fact that the meter *is* built into the camera. For such photographers and for those who work with multiple lighting and wish to balance it carefully, a separate instrument is preferable. It is much easier to carry such a meter around the 'set' and take separate readings from lamps or various parts of the subject than to carry the camera and peer through its viewfinder.

The separate exposure meter also comes in many forms – some very sophisticated – and can include scales that give a great deal more information than the simple mark and pointer of the TTL meter. It can also, because it does not have to be miniaturised, use selenium for its light sensitive element. The advantage of selenium is that although it is less sensitive, size for size, than cadmium sulphide, it does not need a battery. It actually generates an electrical current that varies with the amount of light falling on it, while cadmium sulphide is a material the

electrical resistance of which varies with the strength of the light falling on it.

Contrary to the impression often given, the selenium meter can be made sensitive to quite weak light. Although some CdS meters are sensitive to even weaker light, the value of this extra sensitivity is doubtful. In such conditions, any meter can give only a vague indication of the exposure required, which depends entirely on the result the photographer wants.

In addition to the TTL meter and the separate instrument, there is also the meter built in to the camera but not reading through the lens or coupled with the camera controls. This may be either a CdS or selenium type with a pointer visible in the camera top plate and aperture and shutter-speed markings on a separate setting ring. Frequently, this type of meter uses a 'follow pointer' system, with one pointer or needle linked to the meter settings for film speed and shutter speed and the other moving according to the light falling on the cell and the setting of the meter aperture scale. The pointers are brought into alignment and the aperture and shutter-speed readings are transferred to the camera controls. In some models the meter is connected to the aperture and shutter-speed controls so that they are automatically set by aligning the needles.

Principles of exposure meter operation

The principle of any exposure meter, no matter what its type, is the same. It gives, on any one use, a single reading based on the intensity of the light falling on its cell. It takes no account of where the light comes from or how it is made up. It gives exactly the same reading from a single-toned medium intensity as from a mixture of bright light, deep shadow and everything in between that averages out to the same level. In other words, it pays no regard to the nature of the subject.

Similarly, no matter what intensity it reads, it can give only one answer to the question asked of it – what exposure to give? It must recommend an exposure to give a particular result – a mechanical assessment of correct exposure. It cannot produce one kind of result for one intensity and a different kind for

another. So all meters are calibrated to recommend an exposure that will reproduce any even tone as a tone of medium density and any mixture of tones as a mixture that averages out to a medium density.

What this means in practice is that the meter will recommend different exposures for an even black tone and an even white tone, but that those exposures will both lead to the production of a medium tone on the film. In other words, where the subject is entirely or predominantly a light tone, the meter recommends underexposure. If the subject is entirely or predominantly a dark tone, the meter recommends overexposure. Where, however, the subject is entirely a medium tone or a mixture of darker and lighter tones that average out to a medium tone, the meter recommends the exposure that will produce on the film a range of densities closely approximating those of the original – correct exposure. The meter is calibrated in this way simply because the great majority of photographic subjects *do* average out to a medium tone – or, as the technical jargon has it, they integrate to grey.

Thus, in nearly all circumstances, you can blindly follow the meter recommendation and obtain perfectly exposed films. But if you photograph a model in a dark dress against a dark background, you must give less exposure than the meter recommends unless you want both dress and background to be reproduced much lighter. Similarly, if you photograph a model in a very light-toned dress against a light background, you must give more exposure than the meter recommends unless you want both dress and background to be reproduced much darker.

In colour, you have to remember, too, that underexposure makes colours more saturated, while overexposure reduces the lighter colours to pastel shades or may burn them out completely, so that a pale pink dress may reproduce as white.

Once you understand these facts, you have the basis of all exposure meter usage, whether the meter is built into the camera (TTL or otherwise) or is a separate instrument.

If the subject has a reasonably even distribution of tones, you can take the meter reading as accurate. If it has a predominance of light or dark tones, you have to interpret the reading and set the camera controls differently to obtain the result you require.

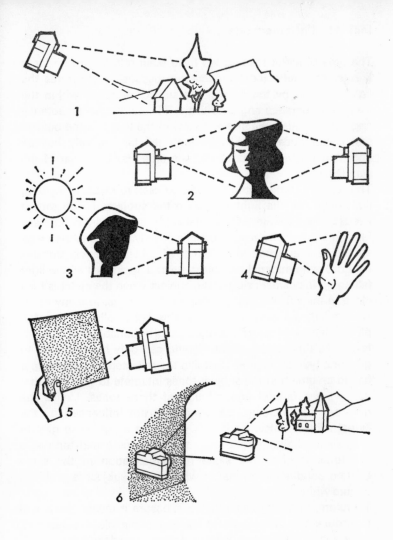

Metering methods: 1, Point camera downward if view includes a lot of bright sky. 2, Take average readings of contrasty subjects. 3, Close-up readings are advisable for backlit subjects. 4, The hand can be a good substitute mid tone. 5, The standard mid-tone is an 18 per cent reflectance grey card. 6, Move forward to avoid influence of nearby dark patches.

Incident-light methods

The type of meter reading we have been referring to so far is known as a reflected light reading, because it measures the light reflected by the area of the subject or scene within the meter's acceptance angle. With the TTL meter, the acceptance angle is obviously the angle of view of the lens and the built-in meter that does not read through the lens usually has an acceptance angle of about 40° – a little less than that of the standard lens.

The separate meter can, however, be used to measure incident light – that is, the light falling on the subject. To do this, it needs to have a wider acceptance angle, because light generally falls on a subject from all directions. Ideally, therefore, the meter should have attached to its 'window' a hemispherical translucent diffusing material that picks up and scrambles all the light falling on the camera side of the subject when the meter is held close to the subject and pointing to the camera. In many cases (particularly on built-in meters), this light collector is a flat plate, which is a compromise that works reasonably well.

Naturally, this incident light reading can only be calibrated to give one type of reading. Just like the reflected light reading, it has to assume that the subject tones integrate to grey and that you want a faithful reproduction of those tones. Unlike the reflected light reading, however, it is not influenced by the actual subject tones. So it tells you what exposure to give in the existing lighting conditions to reproduce a mid-tone *as* a mid-tone. It gives the same recommendation in the same lighting conditions, no matter whether the subject is jet black or pure white.

Therefore, in theory at least, the exposure it recommends will reproduce the white subject as white, the black subject as black and all intermediate tones in their correct densities.

Why, then, do we ever use the reflected light reading? Why, indeed? There are many photographers who believe that there is no answer to that question and that all readings should be of incident light. The real answer is that the reflected light reading works adequately for most photographers and the reflected light meter is easier to make than the truly accurate incident light

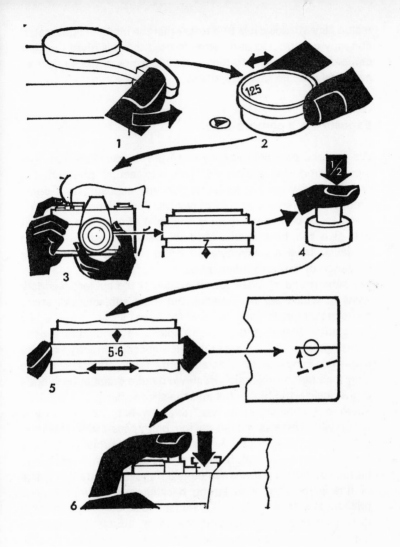

Using TTL meters: 1, Wind on film. 2, Set shutter speed. 3, Focus. 4, Switch on meter (various devices are used). 5, Set aperture to line up meter needle. 6, Press shutter release gently.

meter. Nevertheless, it is true to say that the incident light meter, correctly constructed and correctly used, always gives the best compromise exposure to reproduce the tones of the subject as accurately as the film will allow.

Exposure is a compromise

We say 'the best compromise exposure' because we are now moving from the realms of theory to actual photographic practice and we have to admit that any exposure is a compromise. It is never possible to say that for a given subject in a given set of conditions there is one level of exposure only that will give the best result. Modern black-and-white films in particular have considerable exposure latitude, which means tolerance of over or underexposure.

We cannot underexpose too drastically if the subject has dark areas in which we need detail, but most subjects will stand overexposure in the order of $4 \times$ (two lens stops or four times the shutter speed) and still be capable of producing a print indistinguishable from that of the theoretically correctly exposed negative. Exposure is generally only fairly critical with the long tone range subject in which we require detail at both ends of the scale — the highlights and the shadows.

There are subjects, however, that no film can reproduce accurately. There is a limit to the brightness ratio (the ratio between the lightest and darkest parts of the subject) that any film can reproduce and, in such cases, the exposure has to be biased towards the tones we consider most important. Typical of this is the shot with strong backlighting, perhaps from a brilliant sky. If we want this subject to show detail in both main subject and background, we are in trouble, because the film just cannot handle such extreme contrasts. The only solution is to flatten the contrast by extra lighting from the front — known as fill-in lighting (see page 162).

Colour film has less latitude than black-and-white because it has both colour and tone to consider. Again, if the subject is contrasty, the film cannot reproduce correct colour at both ends of the scale. The averaged-out exposure recommended by the

meter may deal adequately with all the mid-tones, but produce colour distortion in both highlights and shadows. Again, we have to compromise or adjust the lighting.

We arrive, therefore, at four important conclusions regarding the exposure meter:

1 It cannot think. It is a mindless automaton which assumes that you are always asking it to recommend an exposure that will produce tones on the film that integrate to grey, no matter what tones it actually reads.

2 When used as a reflected-light meter, the nature of the subject affects its reading to the extent that it attempts to produce identical results on the film (in terms of average tonal value) for every subject. You have to adjust its reading for subjects that are predominantly light or dark.

3 When used as an incident-light meter it always assumes that the subject tones integrate to grey and it cannot be misled by the actual subject tones. It recommends an exposure which, because it is based on a mid-tone, should be able to reproduce nearly all tones correctly.

4 An incident-light reading and a reflected-light reading from a mid-tone should be identical.

These conclusions lead us to the actual practice of using an exposure meter.

Reading the normal subject

The amount of light a film needs to produce an image depends in the first instance on its speed or sensitivity. So the first thing to do with any exposure meter before attempting to use it is to calibrate it to the speed of the film in use This is usually a case of turning a disc or some such control until the correct ASA or DIN figure (see page 44) appears in a cut-out or opposite a mark. On SLR cameras with TTL meters, the speed setting is often incorporated in the shutter-speed knob.

With CdS meters, built-in or otherwise, the next step is usually to switch the battery into the circuit. TTL meters have a variety of switches, sometimes incorporated with other controls such as the lever wind or the shutter release. The reflected-light

meter is then ready to be pointed at the subject to take a reading. In most cases, as we have said, that is all there is to it. You point the separate meter at the centre of your picture area and, according to type, either read off the aperture and shutter speed indicated by the needle and set them on the camera controls or you move the needle to a mark or pointer and then read off the settings.

With the TTL meter reading the whole screen area, you compose and focus the picture and move the camera controls for aperture and/or shutter speed until the viewfinder readout indicates that the controls are set for correct exposure.

On automatic exposure models, you simply set the aperture or shutter speed, according to model, and leave the meter to set the other control.

If your TTL meter reads only a portion of the screen image, you must line-up that portion on a mid-tone. If you just point the camera at the subject and the meter reads only a light tone, it will recommend underexposure, resulting in a thin negative with little or no detail in the shadows or a dark, degraded colour transparency. If the meter reads only a dark tone, you may obtain a negative with unprintable empty highlights and unnaturally light shadows or a light, washed-out colour slide.

Reading the unusual subject

Thus, for straight reflected-light readings from normal subjects with a reasonably even distribution of light and dark tones, the procedure is simple and you should obtain correct exposure every time.

It is when we come to the unusual subject that trouble starts. To take an extreme example, suppose you are shooting a bathing beauty on the beach with the sea as a background. The sun is shining brilliantly, the sky is clear and the sea is a mass of glittering reflections. It is likely in those circumstances that your model consists mainly of mid-tones and that the whole of the rest of the picture area is reflecting a great deal of light. Despite the enormous amount of light it receives, the meter (any meter) reads the subject as a collection of tones integrating to grey and decides that such a subject needs only a very short

exposure indeed to be reproduced as such a collection of tones. The result, in black-and-white, is a very dark-skinned beauty with grey whites to her eyes and bad teeth, against a distinctly unsparkling sea. In colour, the dusky skin is even more noticeable and the sea becomes a brilliant blue or green with tinged surf and reflections – classic effects of underexposure.

What should you have done? That depends largely on the type of meter you use. With the separate meter, the answer is simple. You approach your model closely and take a reading from a part of her body that approximates to a mid-tone. Moderately tanned flesh is perfect – or her costume or hair may be suitable. Make sure you take the reading from a part to be included in the picture and therefore in the correct lighting and that you do not throw your own shadow over the part you are reading.

You can do the same thing without the close approach, of course, if your TTL meter is the spot-reading type. If it reads the whole image area, you have to take the camera up close, read the appropriate area (considerably out of focus) and disregard the needle position when you shoot.

If your model is not so approachable, you can use a mid-tone not in the picture area, such as the back of your hand, for example, provided you hold it in such a position that the light falls on the part you measure in the same way as it does on the part of the subject you wish to photograph.

The same applies, of course, if your subject is excessively dark, such as a soberly attired gentleman against dark oak panelling. A straight reading is liable to show him in a natty grey suit against pine with an oak grain.

Naturally, you do not always want to use these subterfuges to disillusion your meter. You may want it to be deluded. You may prefer your bathing beauty against the glittering sea to be rendered in silhouette – a completely detailless figure on a really brilliant background. Then you may well need to encourage the meter in its idiosyncrasies. You want to underexpose to an even greater extent than the meter recommends. To do that, you simply take a direct reading from the background only and perhaps close down the lens one stop further. Much depends on the type of result you want, the brilliance of the backlighting and the characteristics of the film. In fact, a satisfactory true

silhouette is unlikely to be achieved in the conditions des-
cribed because the sand would throw up too much frontal
light and too much underexposure would lose the brilliance of
the sea background – particularly in colour.

Using the incident-light meter

Most of the problems we have mentioned so far are overcome
by the use of a properly designed incident-light meter. We
noted on page 76 that the incident-light meter is totally
uninfluenced by the actual tones of the subject. Used correctly,
it reads only the strength of the light falling on the subject and
gives an exposure that will produce a mid-tone as a mid-tone.
Provided the rest of the tones of the subject are within the tonal
range the film is capable of reproducing, they, too, must be
reproduced correctly by that exposure. Thus, even if the subject
contains a predominance of light or dark tones, the incident-light
reading will recommend an exposure to reproduce them
correctly on the film.

To use the incident-light meter, you approach the subject as
closely as possible and, with your back to the subject, point the
meter *at the camera*. (There is a theory that if the diffusing
medium of the incident-light meter is flat, you point the meter
halfway between the camera and the light source – but such a
meter is a compromise design, anyway.) The reading so obtained
should give you an exposure that will reproduce the tones of the
subject as you see them through half-closed eyes – that is,
with rather deeper shadows than you see normally, because the
eye tends to accommodate itself to peering into shadows. If
that is not what you want – if you want to bring out more detail
in the shadows, for example – you have to adjust the reading
and, in this case, give perhaps one stop more exposure. Or, if
there is very delicate detail in the highlights that you wish to
preserve, even if the shadows block up in the process, you might
give one stop less exposure.

Similarly, if your subject has very little shadow and even that
is of no importance, you can give a shorter exposure because
you have much more latitude at the highlight end than you

have in the shadow areas. On the other hand, if your subject is predominantly dark and the highlights are of no importance, you can give extra exposure to bring out shadow detail. On colour film, you then also render all the colours in the scene lighter. If you shorten the exposure to retain highlight detail, you make all the colours more saturated and brilliant.

Effect of camera attachments

The readings given by a meter that does not read through the camera lens need to be adjusted in a variety of circumstances other than those already mentioned. The most obvious example is the use of filters (page 168). Filters are frequently used with both black-and-white and colour film and, with the exception of the UV filter (page 171), they all absorb a certain amount of light and prevent it from reaching the film. Naturally, as the filter is on the lens, the TTL meter takes account of it because the light does not reach the meter cell either. With the ordinary built-in meter or the separate instrument, however, the reading is generally taken from the unfiltered, full-strength light. Fortunately, the adjustment needed is relatively straightforward because all filters have an exposure factor, expressed as $1\frac{1}{2}\times$, $2\times$, $3\times$, etc, or 1.5, 2, 3. These factors indicate that the normal exposure-meter reading has to be multiplied by 1.5, 2 or 3 to take account of the light lost. Thus, if you expose through a $2\times$ yellow filter and the exposure reading from unfiltered light says 1/125 sec at $f8$, you actually give 1/60 sec at $f8$ (twice as long) or 1/125 sec at $f5.6$ (twice as much).

It is rather less easy to calculate the effect of using close-up equipment. When you want to take pictures at very close range, you have to use supplementary lenses (page 125), or extension tubes (page 120) or bellows (page 122). Supplementary lenses have no effect on the exposure in normal circumstances, but the effect of introducing bellows or tubes between the lens and the camera is to increase the distance the light has to travel from the lens to the film. As the light rays leaving the lens are diverging, the result is to spread the total amount of light transmitted by the lens over a larger area and to reduce the

intensity of the light actually falling on the film. The amount of light falling on the film is, in fact, inversely proportional to the squares of the distances involved. For example, a 50 mm lens at infinity focusing position is 50 mm from the film. If we increase its distance by interposing a 25 mm extension ring, the proportion is $50^2:75^2 = 1:2\frac{1}{4}$. The strength of the light on the film is reduced to less than one-half.

Thus, we can say that the use of a 25 mm extension tube on a 50 mm lens involves an exposure factor of $2\frac{1}{4}$ and, as the same calculation holds good for all focal lengths and extensions, we can express it quite simply as $\left(\frac{E}{F}\right)^2$, where E is the total extension (focal length of lens plus length of tubes or bellows extension) and F is the focal length of the lens.

This calculation ignores the normal focusing travel of the lens, which moves farther away from the film as we focus closer. The extent of this movement is generally quite small and has no significant effect on exposure, but there are many wide-angle lenses and an increasing number of standard lenses that can focus down to less than 0·3 m or 12 in. Then, the additional extension of the lens begins to be significant and, in colour at least, it might be advisable to add an extra half-stop exposure.

Again, none of this concerns the user of a TTL meter, which automatically takes care of any additional lens extension by metering only the amount of light that reaches the film.

Precautions with TTL meters

The through-the-lens meter is certainly less influenced by the use of accessories, different lenses and so on than the separate meter or the ordinary built-in type. You must not regard it, however, as a superior type of meter in itself. It works in exactly the same way as any other meter (unless it is the so-called spot-reading type) and, in fact, there is virtually no difference between the separate instrument and a TTL meter used with the standard lens. Both have roughly the same angle of acceptance and will give exactly the same reading in normal circumstances.

Even the ability of the TTL meter to read through filters is no at

total advantage. It has to be used with some caution when deeply coloured filters are involved. Some meters are rather more sensitive to red light than the film is, and you may find it necessary to give a little more exposure than the meter suggests when you use strong orange or red filters.

Local reading methods

The type of TTL meter that reads only a small part of the image area is sometimes considered to be an advantage because it allows you to take 'local' readings. The whole concept of local readings as it is generally propounded, however, is more than a little suspect. Too often it is said that you should approach your subject closely and take a reading from the most important part, so as to obtain correct exposure for that part. As we have already explained, however, you will obtain correct exposure in that way only if the tone you measure is a mid-tone. If it is dark or light, your meter will recommend an exposure to reproduce it as a mid-tone, which is not usually the result you require.

A similar, so-called duplex method is also often recommended. This is even more difficult to understand because it suggests that you take separate readings from the most important light and dark tones of your subject and take the mean of those two readings as the correct exposure for the whole subject. Apart from the rather complex calculations involved, if this procedure is taken literally, it seems to have little scientific basis. It should, in fact, give an approximately correct answer in practice because it is taking the mean of known underexposure and overexposure, but a single reading from a mid-tone or an incident light reading is easier and more reliable.

Low-light readings

Special problems arise when you attempt to use a meter at low-light levels. The CdS meter is generally more sensitive than the selenium type in these conditions and quite ridiculous claims are often made for it — that it can be used in candlelight,

etc. This can raise difficulties in itself, because you may well be able to persuade the meter needle to move when measuring an area close to the candle flame, but the reliability or even usefulness of such a reading is something else again.

When the light is extremely low, the eye acts selectively. It peers into shadows to make out as much detail as possible. It protects itself against highlights, such as the candle flame or street lamp, by closing its iris a little so that it can see detail there, too. The camera cannot be nearly so selective. It needs a longish exposure to see into deep shadow and has to give the same exposure to the highlights and any mid-tones that may be present. The exposure you give depends on the type of result you require and the range can often be great. A shortish exposure accentuates the low light with deep shadows and, perhaps, clearly defined light sources. A much longer exposure can almost effect a night to day transformation. There is a wide variety of effects obtainable between these two extremes.

What can your meter tell you in these circumstances and how do you use it? If you point it into the shadows, you probably get no reading at all. If you point it at an area near the light source, you get an exposure to reproduce that area as a mid-tone. Is that what you want? Remember, the meter gives you an exposure to reproduce the area you point it at as a mid-tone or a collection of tones integrating to a mid-tone. If you can judge that a certain area of the scene should be so reproduced, that is the area to measure and your exposure should be reasonably accurate.

If you want mainly reflections on wet ground, for example, with the rest of the scene hardly registering at all, a measurement of a large area of reflection – or, depending on the nature of the reflection, of an area containing both reflection and dark area – will give a close approximation of the exposure you require.

If you want only lighted display signs, etc, a reading more or less directly from those signs theoretically needs to be increased somewhat to prevent those signs being underexposed to reproduce as a mid-tone. But the increase should not be too great if you want the greatest contrast in the scene and detail in the signs.

Thus, exposures in poor light are largely a hit-and-miss affair. It is almost impossible to forecast exactly what result you will obtain, and accurate assessment is totally beyond the capability of any exposure meter. On most such occasions, in fact, your best procedure is probably to introduce a tone into the scene that you can measure and then base a series of exposures on the reading so obtained. You can, for example, take a reading from a newspaper held in the most brightly lit area and guess that you probably need a stop or two more than that. The procedure then is generally to bracket your exposures. That entails giving one exposure at, perhaps, one stop more than the meter reading, and others at two, three, and maybe even four stops more. When the film is processed, you select the best results.

Automatic exposure

Automatic exposure models can raise problems in themselves. They are programmed to treat every subject as average and cannot cope unaided with strong backlighting, special render- ings of low-light subjects, etc. Many such models have exposure compensation settings. You simply turn a dial to —1, —2, +1, +2 or similar settings to give one or two stops more or less than the normal meter operation allows. These controls are, in effect, altering the film speed setting and, if the camera has no such compensator, you can obtain the same effect by setting a lower film speed to obtain more exposure or a higher film speed to obtain less exposure. But do remember to restore the correct film speed setting for normal shooting.

Long exposures are a particularly difficult field for auto exposure systems. There are many models that, with the aid of electronic shutters (see page 39), can give exposures of 10, 20 or even 30 seconds. Few films react normally to such long exposures. Reciprocity law failure (see page 195) sets in and any indicated exposure longer than one or two seconds is likely to be very inaccurate; it generally leads to considerable underexposure and, with colour films, uncorrectable colour distortion. If you do much long-exposure work, ask the film manufacturers for the exposure and filter corrections necessary with their products.

Lenses for
Reflex
Cameras

One of the greatest advantages of the SLR system is that your camera lens can be removed and replaced by another with different characteristics. This is the interchangeable lens facility which, coupled with the clear vision viewing and focusing screen, makes the SLR such a versatile camera.

The usual reason for replacing the lens is that the angle of view of the lens on the camera is either too small to include a tall building at relatively close range or too great to produce a reasonably large image of a person at 30 ft. For the former, you might want a lens with a 75° or greater angle. For the latter, 15-20° might be enough.

Angle of view and focal length

The angle of view a lens provides is governed by its focal length (roughly, the distance from the lens, when focused at infinity, to the film) and the size of the film with which it is used. Every lens gives a circular image which falls off in illumination and in definition towards the perimeter of the circle. In a camera, however, only the central portion of this image corresponding to the image area of the camera is used.

The angle of view is usually expressed on the diameter of the image area with the lens focused at infinity (as far back toward the film as it will normally go). It can easily be calculated by erecting, from the centre of a line representing the diameter of the image area, a perpendicular representing the focal length of the lens. Actual measurements or scaled-up or down versions can, of course, be used. The angle enclosed by lines drawn from the top of the perpendicular to the two ends of the horizontal line is the angle of view of that lens or any lens of the same focal length when it is focused for a distant subject. It can be seen that as the lens is focused closer, the perpendicular line, representing the distance between the lens and the film, increases in length, and the angle of view therefore becomes smaller.

We generally regard the 50 mm lens as the standard focal length for a 35 mm camera. The reasons for this are a little complicated, but are based on the fact that its angle of view generally

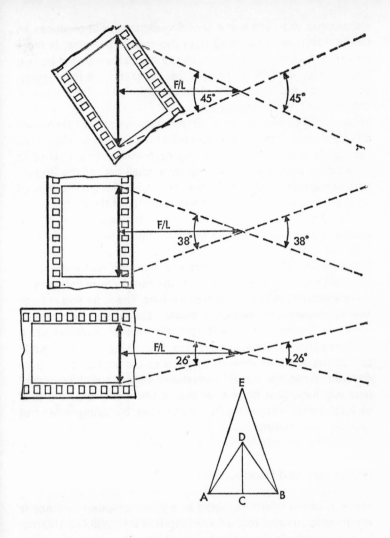

Angle of view. The angle of view of a lens may be expressed on the diagonal, horizontal or vertical dimension of the film. You can calculate the angle by drawing a vertical line of the focal length of the lens from the middle of a line of the film dimension, then measure the angle ADB. The angle EAB indicates the narrowing of the angle when the lens is extended for close focusing.

encourages us to use it at a shooting distance that produces an image which, when viewed from the correct distance, is more or less in the same perspective as the image seen by the human eye. Correct viewing distance in this context is the focal length of the lens used to take the picture multiplied by the degree of enlargement of the final image.

Thus, a 10×8 in print from a 35 mm negative should theoretically be viewed from about 16 in when the picture is taken with the standard 50 mm lens. It is evident, however, that a 10×8 in print could be produced from quite a small part of the 35 mm negative area and is more likely to be viewed from a distance of 10–12 in, which rather destroys the validity of the theory.

In fact, if you do enlarge only a part of the image given by the standard lens, you produce a picture identical to that taken by a lens with a narrower angle of view – a long-focus lens – because the perspective impression given by any photograph depends in the first instance on the distance of the camera from the subject, irrespective of the focal length of the lens. The more you enlarge the photographic image, however, the more its granular structure becomes apparent and the less critically sharp it appears at normal viewing distances. Thus, it is always preferable to suit the angle of view of the lens to the subject area to be covered. When the subject is relatively distant and the standard lens will include a large area that is not required in the final picture, better image quality is obtained by using a lens of greater focal length.

Image size and focal length

The size of the image obtained at a given shooting distance is strictly proportioned to the focal length of the lens. The 100 mm lens, for example, images objects on the film at exactly twice the size of the images provided by the 50 mm lens used at the same shooting distance.

Naturally, occasions also arise when the angle of view of the 50 mm lens is insufficient to cover the area we wish to reproduce in the picture. Then a lens of shorter focal length – wider angle of view – is used. A wide-angle lens takes in more of the scene

Page 94, top: Reflector, or cat's eye, shot at close range and with a wide aperture for selective focus – *Adrien Masui.*

Page 94, bottom: Reflection, or human eye, with an image in view. Focus must be on the reflection – *J. P. Holtom.*

Page 95: A low viewpoint and close approach allow the subject to assume a vaguely threatening arrogance – *Alan Lewens, Harrow School of Photography.*

Congested traffic is well illustrated by the stacking-up effect of a long-focus lens – *Leslie Turtle.*

Page 96, top: Deliberate grain emphasis effectively conveys the gloom of night time at the dockside – *Michael O'Cleary.*

Page 96, bottom: Oblique reflections can have strange effects that are worth watching for – *Michael Barrington-Martin.*

in front of the camera, but on a reduced scale – again, in proportion with its focal length.

Focal length and light transmission

The design of the SLR camera is such that there is no theoretical limit to the range of lenses that can be used with it. There are, in fact, extreme wide-angle lenses available that can cover an angle of more than 180°. There are very long-focus lenses that cover an angle of only 2 or 3°. The limit at this end is imposed purely by matters of practicability. The focal length of a lens is, generally speaking, the distance of the lens from the film plane when it is focused on a distant subject. As most 35 mm cameras are of rigid construction, this means that the long-focus lens has to be mounted in a tube to provide the necessary distance. Although a special design allows this distance in some cases to be smaller than the focal length, any increase in focal length inevitably means that the lens and its mount becomes rather bulky.

Furthermore, to provide the same light-transmitting ability as the shorter focus lens, the long-focus lens has to be of greater diameter. This is because the light transmitting ability of a lens depends partly on the distance it has to project the image. The long-focus lens has to project the image to the film over a greater distance than the shorter focus lens. The longer focus lens must therefore collect more light in the first place, and to do that it requires a larger front glass – roughly in proportion to the difference in focal length. Thus, to provide the same light transmitting ability as a 50 mm lens, a 1000 mm lens needs a front glass about 20 times as large.

The factor that actually governs the light transmitting ability of a lens is the effective aperture, which is the diameter of the light beam entering the lens and passing through an aperture in the diaphragm contained in virtually all modern lenses. As the diaphragm is always within the lens, the front glass of which is generally a converging or positive lens, the effective aperture is usually rather larger than the actual diameter of the opening in the diaphragm.

Light transmission and *f*-number

We express the light transmitting ability of a lens by a series of numbers related to the size of the effective aperture. These are called *f*-numbers, and they run in the progression 1, 1.4, 2, 2.8, 4, 5.6, 8, 11, 16, 22, etc – each succeeding number being the previous number multiplied by $\sqrt{2}$, with a little rounding-off for convenience. These numbers are, in fact, derived from the focal length of the lens divided by the effective aperture and are known as relative apertures. They are so arranged that at each smaller number the light-transmission is twice as great as at the next larger number.

Thus, for a lens to have an *f*-number of 1, the focal length of the lens and the effective aperture have to be the same. This is feasible, although rarely encountered, with a 50 mm lens, but is inconceivable with a 1000 mm lens, which is why the longer focus lens tends to have a smaller maximum relative aperture than the shorter focus lens. It is also why there is, in practice, a limit at the upper end to the range of focal lengths that can be supplied. The longer the focal length, the smaller the maximum relative aperture has to be in order to make the lens a practicable manufacturing proposition. But the smaller the maximum aperture, the less useful the lens becomes for photography.

Principle of telephoto lens

Long-focus lenses are often described indiscriminately as telephoto lenses. In fact, the telephoto lens is a special construction which allows the physical length of a lens to be less than its focal length. We have explained that the focal length is the distance of the lens from the film plane when the lens is focused on a distant subject. This distance is, in fact, measured from the optical centre of the lens. The telephoto construction is such that the optical centre is moved forward and is usually competely outside the lens. Thus, the back focus (the distance from the rear element of the lens to the film plane) can be reduced and the lens no longer needs the long tube which is normal in long-focus lens construction.

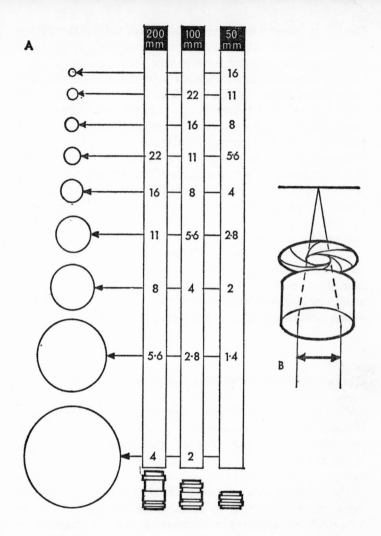

Effective aperture: **a,** Apertures for given *f*-numbers vary in size according to the focal length of the lens. The same size aperture can be *f*8 on a 200mm lens or *f*2 on a 50mm lens. **b,** Effective aperture is diameter of light beam entering lens and passing through diaphragm opening.

The telephoto lens can be recognised from the fact that its rear element is usually at the back of the mount and that the lens barrel is shorter than the focal length. This has resulted in the construction of extremely compact 135 mm lenses, for example, and in some cases, even up to 200 mm. Beyond that, the long-focus lens is still a substantial item, and at even longer focal lengths the telephoto construction becomes impracticable and the normal long-focus construction is used.

The telephoto principle is used in reverse for wide-angle lenses, the reason this time being that reflex cameras need space behind the lens to house the movable mirror that provides the screen image. It is evident that, with very short-focus lenses, the rear element of the lens would encroach on the space required for the mirror. Such lenses therefore make use of the inverted telephoto or retrofocus principle, by which the back focus is increased so that the lens can be moved farther away from the film plane. The retrofocus lens can often be distinguished by its rather large front element. The principle is sometimes used in standard as well as wide-angle lenses.

Diaphragm construction and operation

We have mentioned the diaphragm of the lens and its related f-numbers. The diaphragm is generally a metal-bladed construction which can be opened and closed to provide an infinitely variable more or less circular opening to control the amount of light allowed to pass through the lens. The f-numbers relate to certain sizes of opening, as already described, and are what we are referring to when we talk loosely about the 'aperture' for exposure and depth of field purposes. The numbers are engraved on the lens barrel and the diaphragm itself is opened or closed by a ring around the barrel with a mark on it which is set against the f-number required. On most modern lenses, this ring clicks into position at each engraved figure and at a mid-point between each figure. This is the click-stop principle which enables you to set your lens to a given f-number without looking at it. You simply count the

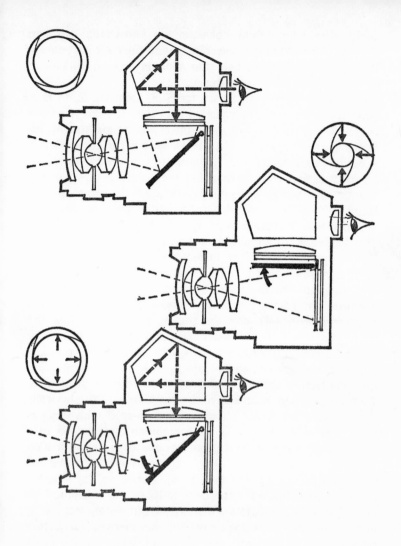

Automatic diaphragm. Lens diaphragm is wide open for viewing and focusing. As you press the shutter release, the mirror moves up, the diaphragm stops down to the preset value, and the shutter opens. When the shutter closes, the mirror returns and the diaphragm reopens.

clicks. The intermediate positions are known as half-stop settings, and although the diaphragm opening is actually infinitely variable these half-stop settings make it difficult to set further intermediate apertures.

The aperture control on lenses for SLR cameras is, in fact, generally rather more complicated than this. The image on the SLR viewfinder screen is at its brightest and is most suitable for focusing (see page 23) when the lens is set to its maximum aperture. It is inconvenient, however, to have to open the lens up for focusing and viewing and then close it down to the shooting aperture for every picture. Except in the very long focal lengths, therefore, most lenses for SLR cameras are now provided with automatic diaphragm mechanisms.

The diaphragm of an automatic lens is not controlled directly by the aperture ring. This, in fact, merely sets a stop at the diaphragm size required. The diaphragm itself remains fully open until the shutter release is depressed. It closes to the preset aperture just before the shutter opens and reopens to full aperture immediately after the shutter has closed. Thus, the camera is always ready to view and focus the next picture.

The automatic diaphragm is generally operated by pressure from a mechanism within the camera body on a pin protruding from the back of the lens and connecting with the diaphragm. This construction becomes rather unreliable with physically long lenses, which are often provided instead with what is known as a preset diaphragm. A common construction of a preset diaphragm lens involves the use of a spring-loaded aperture control ring. This ring is pushed forward toward the front of the lens against the spring, turned to the required f-number and allowed to fall back to its normal position. This operation does not close the diaphragm, but merely sets a stop in the same way as the ring on the automatic lenses. Just before releasing the shutter, you turn the aperture control ring to its limit in the closing direction and the diaphragm closes to the aperture preset. After the exposure, you reopen the aperture by turning the ring in the opposite direction.

There are still a few lenses with diaphragms that are totally manually operated in the manner of lenses on non-reflex cameras, but these are gradually becoming rare items. In the

wide-angle, standard and medium long-focus range, nearly all lenses are fully automatic.

Zoom lenses

To make full use of the interchangeable lens facility of the SLR camera, you may consider that you need to carry at least three lenses with you on your photographic outings. Even with today's compact designs, that is quite a weight and bulk. There are, however, some special lenses that are really several lenses in one. These are lenses of which the focal length can be varied within limits. They are known as zoom lenses and, as their focal length is infinitely variable within the range provided, they enable you to fit the subject exactly to the image size required. This can be a useful facility for the colour-slide worker who has little opportunity for subsequent cropping of the image.

The zoom lens is a complicated construction, using movable elements within the lens barrel controlled by a ring on the outside. As you turn the ring, the focal length of the lens changes and the size of the image in the viewfinder changes in proportion. The extent of this change is never very extensive; it rarely exceeds 5:1 and is more likely to be about 2·5:1 and is generally in the longer focus zone such as 80–200 mm. As the design becomes more popular and less expensive, however, the variety of ranges increases. Nevertheless, the zoom lens remains rather expensive and it is unlikely that you will obtain as good quality images from it as from the fixed focal length lenses of reputable manufacturers.

The true zoom lens maintains its focus over the whole zoom range and it is generally advisable to focus the image with the lens set to its greatest focal length and then to move the zoom control to the required position just before taking the picture. This is because focusing is more positive with the longer focus than with the shorter focus lens (see page 114). When you reset the zoom after focusing in this way, the image remains in focus. A few lenses are now appearing, however, which do not have this facility. They should properly be described as variable

focal length lenses because, although you can vary the focal length in the same way as the zoom lens, you have to refocus the image every time you operate the focal length control. In still photography, this is not really much of a drawback and the advantage of this construction is that such lenses can be made more cheaply and with a wider ratio of focal length change.

There is no way, however, of avoiding the greatest disadvantage of the zoom lens, which is that, for the majority of your photography, you are carrying unnecessary bulk — and that bulk is, moreover, on the camera and not in your accessory bag. A further disadvantage is that the maximum aperture of the zoom lens is generally controlled by the maximum focal length, so that at the shorter focal length settings you have a significantly smaller maximum aperture than you would have with a lens of normal construction. The minimum focusing distance is similarly controlled and may be rather long for the shorter focal lengths.

Mirror lenses

A further special type of long-focus lens has been devised to eliminate the disadvantage of the enormous physical length of such lenses of conventional design. The principle used is to compress the light path into a shorter physical distance by folding it up. This is achieved by reflecting the light passing through the lens from a mirror at the back of the lens to another in the front and then back through a central opening in the rear mirror. Some lenses of this type also incorporate conventional lens elements. The technical terms for these lenses are catoptric for those using mirrors only and catadioptric for those incorporating conventional lens elements, but both types are universally described as mirror lenses.

Although the mirror lens is much shorter than the normal long-focus lens of the same focal length, it has a considerably greater diameter. Nevertheless, the 500 mm mirror lens is a better proposition for hand holding than a lens of normal design. The main disadvantage is that the mirror lens cannot have a diaphragm of normal construction. Its light transmission is

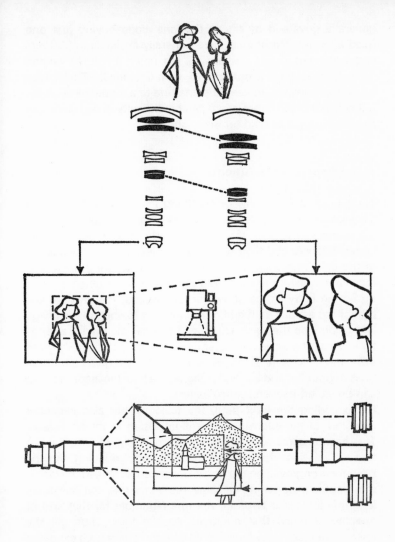

Zoom lens. The zoom control changes the position of some lens elements to alter the focal length and give various reproduction ratios from the same position. The effect is the same as enlarging part of the image. The zoom can do the work of several prime lenses.

generally governed by filters, the lens alone having just one fixed aperture. Mirror lenses are generally available in 500 mm and 1000 mm focal lengths, with maximum apertures varying from lens to lens according to manufacturers. There is a tendency, however, to keep the aperture to a moderate $f8$ or so. If it is made much larger, there can be difficulty in obtaining the necessary depth of field for many shots.

Teleconverter attachments

There is yet another way of obtaining the effect of long-focus lenses. Various converter lenses are available for fitting between the camera lens and the camera body. These are, in fact, negative lenses and their function is to lessen the convergence of the light rays from the camera lens and to bring them to a focus at a greater distance from the lens. This distance is taken up by the body of the converter lens so that the rays are still brought to a focus on the film. The result is to enlarge the image and to provide the same effect as a picture taken with a long-focus lens. The basic converter lens of this type generally gives a $2 \times$ magnification. There are also models that give magnifications of both $2 \times$ and $3 \times$ and some with which the magnification can be varied between those limits.

By extending the light path, the teleconverter also causes a reduction of the intensity of the illumination in the film plane. This has the same effect as in the normal longer focus lens, so that the relationship between the diaphragm opening and the f-numbers engraved on the lens is destroyed. When, for instance, the diaphragm opening remains the same size but the focal length is increased twofold, the true f-number for that size of opening is twice that engraved on the lens. Thus, all the aperture numbers on a lens should be doubled for both exposure and depth of field calculations when a $2 \times$ teleconverter is in use and trebled with a $3 \times$ converter. The greatest effect of this, of course, is that the maximum aperture available becomes two stops less than that of the camera lens. A 135 mm $f2.8$ lens, for example, becomes a 270 mm $f5.6$ lens when used with a teleconverter. An advantage to offset against this that can

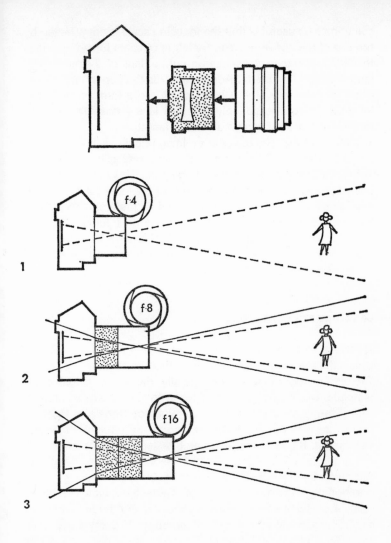

Converter lens. The tele-converter fits behind a camera lens. 1, Lens set to f4 without converter. 2, Lens still set at f4 but 2X converter magnifies image and reduces illumination to effective f8. 3, Lens set at f4 with **two** 2X converters gives further magnification but reduces effective illumination to f16.

107

sometimes be useful is that the focusing scale is not affected by the use of the converter. You therefore obtain a long-focus lens that focuses rather closer than a normal lens of a similar focal length would be able to. Additionally, as the converter actually turns the lens to which it is attached into a form of telephoto lens, you have a reasonably compact lens – possibly more so than many lenses of comparable focal length.

The effect of the teleconverter on image quality is minimal with the best designs. There may be some very slight fall off in definition at the edges of the image area. This may well reach unacceptable proportions, however, in the cheaper models. If you have a good camera lens, it would be preferable to make a $2 \times$ greater enlargement rather than use an inferior $2 \times$ converter. If your camera lens is not of good quality, even the good converter will produce inferior results because all the faults of the camera lens will be exaggerated.

Lens mounting methods

There are two basic ways of effecting lens interchangeability. One is the screw mounting and the other the bayonet mounting. The screw mounting is theoretically the better engineering principle, but it has disadvantages with the single-lens reflex. One disadvantage common to all types of camera is that the screw lens is undoubtedly slower in operation than the bayonet attachment. It takes time to locate the start of the thread and to screw the lens fully home – and there is always the danger of damaging the threads by ham-fisted treatment.

Additionally, however, the bayonet-attaching lens can more easily be aligned with links to the camera body, which is generally a requirement of full aperture TTL metering (see page 72). This is why few screw-mounting cameras have this type of meter and why the Pentacon company introduced an electrical connection for this purpose.

The most widely used mount for many years was the screw mounting of the Pratika, Pentax and many other models. During 1980, however, the final nail of obsolescence was hammered into this system when its originators, the Pratika manufacturers,

brought out a bayonet-fitting camera. Many others had already turned over to the Pentax K bayonet. Thus, almost all mode n SLRs now use bayonet fixings, most of them unique to their particular models and only the Pentax K type being widely used by other manufacturers.

Value and use of wide-angle lenses

The wide-angle lens is a handy addition to your equipment and there are many photographers who consider it to be even more useful than the standard lens. This, however, relates only to the moderate wide angle – such as the 35 mm or 28 mm. These lenses provide angles of acceptance of 64° and 76° respectively, which is adequate for most normal purposes and keeps within the bounds of good performance at a reasonable price.

One of the greatest advantages of the wide-angle lens is that it allows you to take photographers from close range and yet still include the same amount of subject as a lens of longer focal length would cover from a greater distance. Cramped interiors, tall buildings, narrow streets, crowd scenes, and so on are all difficult subjects for the standard lens, but often come easily within the compass of the wide-angle.

Furthermore, the wide-angle lens is particularly suitable for 'grabbed' shots, when there is little time to focus or compose the picture. It can be aimed at a subject quite accurately without even being lifted to the eye. The quality of modern lenses and films is such that good enlargements can be made from quite small parts of the negative. Focusing is less critical than with the lens of greater focal length because, other things being equal, the shorter the focal length the greater the depth of field (see page 38). It is generally possible to set the wide-angle lens to a mid-distance and medium aperture and cover the whole field from a few feet to the far distance. Even at close range, a fairly deep zone can be covered by careful choice of distance and aperture settings.

Despite the great advantages of the reflex focusing system, it is often, in fact, advantageous to focus by scale when using a wide-angle lens. The screen image, particularly when focusing

relatively distant objects, changes very little with quite large movements of the focusing ring and it can be difficult to be sure that the image is sharp. In bad light, it is even possible to make large focusing errors, especially when working quickly. In such circumstances, scale focusing, even by guesswork, is likely to be more reliable.

Many wide-angle lenses can focus at extremely close range, sometimes down to 15 cm or so. This is an invaluable feature when you are photographing flat copy or subjects with very little depth. You can operate without special close-up equipment, and often with short exposures that enable you to hand-hold the camera. If the close-range subject has any depth, however, you may run into focusing and perspective problems. Even with the short-focus lens, depth of field does not extend very far at close range. It can be a matter of inches. You can increase it, of course, by stopping-down the lens, but even that has its limits and you may have to move farther back to obtain the required result.

Image distortion with wide-angle lenses

Perspective troubles can arise from approaching the subject too closely. When photographing a flower or group of small blooms, for example, the parts closer to the lens are reproduced much larger than those farther away and the result is rarely pleasing. For such photography, in fact, the longer focus lens in conjunction with extension tubes or bellows (page 120) is often preferable.

There are other types of image distortion that can be caused by the use of a wide-angle lens. The short-focus lens projects its image to the film at a relatively acute angle. There is, therefore, always a tendency for the part of the image at the edges of the picture to spread outwards. This can be corrected when the projection angle is not too great and is not normally noticeable in the standard lens and sometimes not even in the 35 mm. As the focal length becomes shorter, however, so any spherical, tubular, etc, objects at the edges of the picture are reproduced with greater width on the flat film and therefore appear to be

fatter or distorted in shape compared with similar objects toward the centre of the frame. This applies only to three-dimensional objects. Flat shapes in a plane parallel to the film are not affected by this type of wide-angle distortion.

Another form of wide-angle distortion should be encountered only with the very short-focus lenses – perhaps 24 mm and less. The most noticeable is barrel-distortion, which causes lines at the edges of the frame to bow outwards in the middle. The effect can be that fence posts, for example, in the lower half of the picture can appear to lean outwards the farther they are from the middle of the picture. Straight lines from top to bottom of the picture become noticeably curved. The shorter the focal length, the more noticeable this effect until we reach the true 'fish-eye' effect with the 180° angle lenses that produce a heavily distorted circular image within the 35 mm frame.

Barrel distortion can be corrected to a surprising extent, even in very short-focus lenses, and there are accordingly some extreme wide-angle lenses that show very little distortion at all – but they are generally very expensive.

Vignetting is a fault that is comparatively rare in modern lenses, but it might still be met in some lower-priced, less well-corrected wide-angle lenses. It is caused by the inability of the lens to illuminate evenly a sufficient area to cover the whole 35 mm frame. As the illumination patch formed by the lens is circular, vignetting of this kind generally causes the corners of the image area to be under-exposed and to appear darker in the final print or transparency.

Value and operation of long-focus lenses

The lens of longer focal length magnifies the image in strict proportion to focal length. The 100 mm lens, for example, gives an image twice as big as that obtained with the 50 mm lens. Thus, it can provide the same size image from farther away as the shorter focus lens provides at close range or it can provide a bigger image than the shorter focus lens used at the same shooting distances.

The advantages of this facility are various. A longer shooting

distance, for example, can reduce perspective distortion. If you try to take a large-head portrait with a 50 mm lens you have to approach the subject so closely that nearer features are reproduced unnaturally large in relation to the more distant features. Noses can become over-large, ears rather small and the whole shape of the head thereby distorted. On the other hand, a very distant viewpoint with an exceptionally long-focus lens to provide the same size image can flatten perspective and give the opposite effect. Ears look larger in a semi-frontal view and the distance from front to back of head looks less.

The long-focus lens is obviously advantageous when the subject is relatively small and cannot be approached closely. Architectural features high up on buildings, dangerous wild life, sporting action in an arena to which you have no access, small birds or other timid creatures, and so on, are all subjects for the long-focus lens.

The range of long-focus lenses available for 35 mm SLRs is enormous – from 75 mm or so to 1000 mm and more. Inevitably, however, the greater the focal length the greater the length and bulk of the lens. Telephoto construction (page 98) can alleviate this to some extent, but most lenses of more than 135 mm focal length have to be handled with considerable care to keep them perfectly still during the exposure. It needs only the slightest unsteadiness in holding a long-focus lens to cause the image to judder alarmingly in the viewfinder – and therefore on the film. As the film image is always subsequently enlarged, such movement just cannot be allowed, and if the lens cannot be held steadily in the hand it must be used on a tripod.

This can be quite a drawback. Few people wish to carry a tripod around with them on their photographic expeditions, so the really long lens is not always the great benefit that it might seem to be. A 300 mm lens, for example, enables you to shoot from a considerable distance and to bring up details on subsequent enlargement that are quite invisible to the human eye. But it can only do this if the camera is perfectly steady – and a 300 mm lens is always a bulky object. Even if it has a modest f5.6 maximum aperture, it is about $2\frac{1}{2}$ in across and could be a foot long. Rather than try to hand-hold such a lens, it is likely that you could obtain better results by giving a little

extra enlargement to the image from a 150 or 200 mm lens – or even from a 135 mm.

The 135 mm lens is, in fact, the most popular of the long-focus types. It is nearly always of telephoto construction, reducing its length to around 5 in and there are innumerable makes to choose from. It gives a 2·7 times magnification of the image size from the standard lens, which is suitable for a variety of subjects from head-and-shoulders portraiture to all types of medium-range photography. With auxiliary equipment, it is also suitable for a wide range of close-up work. As it is commonly available with a maximum $f2.8$ aperture, its applications can be considerably increased by adding a $2 \times$ teleconverter (see page 106), giving a 270 mm $f5.6$ lens of compact construction that can generally be hand-held without too much difficulty.

Special long-lens applications

The long-focus lens has undoubted value for certain special applications. Unfortunately, it is often misapplied by photographers who are too timid to approach their subject closely. This is a mistake because, whereas by enlargement the standard lens shot can be made to look like a long-focus shot, the picture taken from a distance with a long-focus lens always betrays its distant viewpoint. It frequently destroys the impact that a picture should have. In action shots, for example, it cannot make a figure dominate among others. It cannot easily provide differential focusing, because of the long range. It tends to scale everything down because the distant viewpoint prevents steeply angled shots – as of steeplechasing horses or high-jumping athletes.

Most ordinary pictuers need the perspective effect obtained by placing prominent features, even main features, relatively close to the camera, where they are reproduced very much larger than more distant objects. This is an important way of giving the impression of space and depth to a two-dimensional reproduction. The long-range shot loses these size differences and therefore looks flatter and most decidedly two-dimensional. Apart from the necessity for a particularly steady hand, the

long-focus lens needs a little extra care in other ways. Because, other things being equal, it provides rather less depth of field than the shorter focus lens, it has to be focused with some care and in some circumstances may compel you to set a fairly small aperture. The plane on which to focus when the subject has some depth must be carefully chosen in conjunction with the depth-of-field scale. If sharpness into the far distance is required, it may even be advisable to forsake the screen image and place the infinity focusing symbol opposite the shooting aperture on the depth-of-field scale and then check the other end of the scale to ensure that the foreground or main subject will also fall within the depth of field. If it does not, the aperture must be reduced and the infinity symbol reset on the depth-of-field scale.

This practise is known as focusing on the hyperfocal distance, which is the nearest point at which a lens will produce a sharp image when focused on infinity. If you put the infinity mark opposite the shooting aperture on the depth-of-field scale, the lens is focused on the hyperfocal distance and depth of field extends from half that distance to infinity. This is the greatest depth of field that any lens can provide at a given aperture.

When the long-focus lens is used at exceptionally long range it may benefit from the use of a haze (pinkish) filter for colour or a yellow, orange, or even red filter with black-and-white. Distant views are often flattened by haze, and the filter can sometimes help to increase contrast and produce a more sparkling picture.

Care and maintenance of lenses

Lenses should be looked after with reasonable care. They should not be unnecessarily exposed to great extremes of heat or cold, which can have untoward effects on the grease used in their movements, and every care should be taken to keep them away from dust-laden air and particularly from sand. It is debatable whether lens cases are very effective, but caps for both front and rear of the lens should be kept in place when the

lens is not in use, and it also helps if they are kept in plastic bags.

With these precautions it should rarely be necessary to clean a lens and, in fact, this should be postponed as long as possible. A small amount of dust on a lens will do no harm, but continual rubbing of the lens with, say, a pocket handkerchief will soon raise a mass of fine scratches on the surface that will at least take the edge off its performance.

The glass-air surfaces of all modern lenses are coated with an extremely thin layer of magnesium fluoride or other comparable substance. This serves to reduce reflections from the glass surfaces and to increase light transmission. The coating can be seen by reflection – that is, when viewed at an angle. It appears to be coloured, but is, in fact, quite colourless and has no effect on colour rendering in the picture. Modern coatings are hard, perhaps harder than the glass itself, but they are microscopically thin and are easily scratched by too vigorous polishing.

If you must clean your lens, use special lens tissues or a lens brush, and hold the lens upside down while you brush the dust off. If you hold it in the normal way, you will probably merely brush the dust into the lens mount. The lens tissue should, incidentally, be used folded and with its edge torn to form a kind of brush. It should not be rubbed over the lens under direct finger pressure.

The one thing you should never attempt to do with a lens is to dismantle it. Lenses for 35 mm SLRs are rather complicated, particularly those with automatic iris mechanisms. They usually have multi-start threads and you can get into a terrible mess trying to put them back together again. If the focusing movement or the iris adjustment becomes stiff, take the lens to a reputable mechanic. It probably needs a thorough cleaning and regreasing or may even have a sheared-off screw or displaced ball-bearing gumming up the works.

Shooting at
Close Range

The 35 mm SLR is a camera that might have been specially designed for close-range photography. Fully interchangeable lenses and screen focusing are essential for this type of work. The SLR provides both features, and its screen image, moreover, comes via a mirror that automatically flips out of the light path during the exposure.

Some standard and wide-angle lenses for SLR cameras focus down to well within the close-up range (45 cm and less) without any extraneous aid, and special macro lenses focus closer still; but for most close and ultra-close work, extra extension is provided by intermediate tubes or bellows. With the 35 mm SLR, these are quite small items and can be rapidly affixed to the camera. The screen image is still the image that will appear on the film, no matter how much extension is interposed, with no parallax troubles. Even at quite long extensions, the large-aperture lenses available provide a bright, evenly illuminated image that is easily composed and focused. In an increasing number of models, no complex exposure calculations are required. The loss of light owing to the increased extension is automatically allowed for by the TTL exposure meter.

There are even various slightly unorthodox methods that can be used without difficulty. Supplementary lenses (see page 125) are not often used on SLR cameras, because it is generally true that the camera lens alone on tubes or bellows gives better quality. Nevertheless, supplementaries can be used to keep exposures short and a method that is growing in popularity is to mount a standard lens reversed on the front of a 135 mm lens to give the effect of a powerful, very high quality supplementary lens. Again, the screen shows exactly what you will get on the film, no matter what combination of lenses you mount on the camera, and the TTL meter provides the correct exposure.

Let us examine these various methods in turn. Camera lenses are positive, or converging lenses. Light rays reflected from any point in front of the lens are diverging when they reach the lens. They are then bent back by the lens so that they converge to reform the point behind the lens. That is how an image is formed. If the lens were a negative, or diverging, type, the light rays would diverge further and could not be made to form an image.

Forming the image

The lens forms an image of a distant subject in a plane at a distance behind the lens equal to its focal length. Thus, the 50 mm lens focused at infinity forms a sharp image of anything in the far distance in a plane 50 mm behind the lens, which is where the film is situated in the camera. It also forms images of objects closer to the camera, but these images cannot be rendered sharply in the film plane (or focal plane) because the lens has a limited power to bend the light rays. The closer objects are therefore reproduced sharply at various distances behind the focal plane. To reproduce them sharply on the film, the distance between the film and the lens has to be increased. This distance is known as the camera extension and the commonest method of focusing an image is to vary the extension according to the distance of the object to be photographed. The closer the object is to the camera, the greater the extension required to image it sharply.

The lenses used on 35 mm SLRs have focusing movements built in, usually consisting of a bodily movement of the whole lens within its mount brought about by turning a ring around the lens barrel. The amount of such focusing travel that can conveniently be built in to the normal lens is limited, although it has tended to increase in recent years. It is now not uncommon for the standard lens (about 50 mm focal length) to focus down to 45 cm (18 in) or less, while a wide-angle lens may be able to focus objects a few inches away. The longer focus lens has a far more restricted close-focusing ability.

Exceptions are some zoom and long-focus lenses that have a so-called macro focusing ability built in (see page 129).

When used with the interchangeable-lens SLR, however, any lens can be made to focus objects at any distance down to a fraction more than the focal length of the lens — simply by separating it from the camera body. No lens can focus an object only one focal length or less away, because it has not sufficient light-bending power to cause the rays from such objects to converge. They emerge from the lens parallel or diverging and cannot therefore form an image.

There are two methods of increasing the separation between the

lens and the camera body — the use of extension tubes or extension bellows.

Uses of extension tubes

The simplest extension tube is just that — a rigid tube to connect the lens to the camera body and to provide the additional extension required. Naturally, it has a thread or bayonet fitting at one end to mate with that on the camera body, and the opposite type at the other end to take the lens bayonet or thread or to enable a further, similar tube to be added.

Now that so many lenses have automatic diaphragm operation, however, the simple tube has a limited use, because in most cases it prevents the lens from being stopped down. Tubes are therefore supplied with mechanisms to transmit the automatic diaphragm movement from the camera body to the lens.

Extension tubes are usually supplied in sets of three adding up to about 50 mm, such as 7, 14 and 28 mm. Together, therefore, they provide what is known as double extension — separating the lens from the camera by a distance of two focal lengths. This is the requirement for producing life-size images on the film of objects at the same distance (two focal lengths) from the lens.

The tubes can, of course, be used separately or in any combination to provide various close-focusing distances and image scales. Additional tubes can be added, too, to give magnified images. Theoretically, there is no limit to the extension, but in practice the light losses soon become unmanageable.

This is one of the biggest drawbacks of using increased camera extension for close-range work. Increasing the length of the light path between the lens and the film spreads the image and thereby reduces the strength of the light forming the part of the image that falls on the film. The reduction is more or less in accordance with the inverse square law (see page 84), so that a doubling of the extension entails a 75% reduction in illumination. The exposure factor for added extension can be calculated from $(\frac{E}{F})^2$, where E = total extension (focal length plus added extension) and F = focal length of camera lens. Thus,

when all three tubes are used with the 50 mm lens the factor is $(\frac{99}{50})^2$ which is as near to 4 as makes no difference. This is the factor by which the normally indicated exposure must be multiplied.

It can readily be calculated that the factor for the 7 mm tube $(\frac{57}{50})^2$ is negligible and that the greater the focal length of the lens, the lower the factor for a given increase in extension. Thus, if all three tubes are used on a 200 mm lens the factor is $(\frac{250}{200})^2$, which is only a little over $1\frac{1}{2}$. The scale of reproduction is, however, much less than with the 50 mm lens because, in order to focus close enough to produce a life-size image, the 200 mm lens would need an additional 200 mm extension.

It follows that, with a given set of extension tubes, the greatest scale of reproduction is obtained from the lens with the shortest focal length. If you put a 28 mm lens on your 49 mm extension, for example, the scale of reproduction (with the lens set to infinity) is about 2:1. The image on the film is about twice life-size. The exposure factor, however, is increased to $(\frac{77}{28})^2$ which is approaching 9.

In all cases when you use extension tubes, you have available the slight additional extension provided by the focusing travel of the lens. This is generally so relatively small as to have little effect on the exposure factor, but with the shorter tubes it does enable you to focus significantly closer than when the lens is set to infinity.

Exposure factor calculations are, of course, only required when the camera has no TTL exposure meter. By taking its readings through the lens, the TTL meter responds to the extension of the light path and the consequent fall-off in light strength.

Focusing the close-up subject

Generally, close-up work with extension tubes is carried out with a tripod-mounted camera because focusing is critical at close range owing to the restricted depth of field, even with the lens well stopped down. Because of the great separation between the lens and the film, the lens focus travel has only a limited effect in this situation. So with small, movable objects,

focusing is best carried out by moving the object bodily toward or away from the camera. The alternative – the only possible method if the object cannot be moved – is to move the camera. That is no easy task when it involves moving the tripod, too, and if you expect to do much of this type of work, a focusing slide is a useful acquisition. This is a simple camera mounting on tubular runners that can be interposed between the camera and the tripod to allow the camera to be moved a few inches forward or back without moving the tripod.

Where the added extension to the lens is relatively small, such as, for example, a single tube on a 135 mm lens, the lens can be focused normally for moderately close-range work. In such circumstances, the camera can generally be hand-held because the light loss is insufficient to make long exposures necessary and focusing is no more than normally critical.

This type of usage is popular with photographers specialising in wildflower and plant photography or close-ups of relatively small details for pattern or texture pictures and is also suitable for any photography of small objects where it is preferable to hand-hold the camera or impracticable to set up a tripod. The method can be used, for example, in conjunction with a small flashgun to shoot documents or notices *in situ*. Whenever the tube length is relatively small in relation to the focal length of the lens used, the focusing travel of the lens allows a reasonable variation in the scale of reproduction.

Uses of extension bellows

Extension bellows serve essentially the same function as extension tubes and are in some ways more versatile in use. The bellows unit is constructed in such a way that the bellows can be extended or contracted by a simple sliding action to allow infinite variation, between certain limits, of the focusing distance and thus the scale of reproduction. The total extension provided is usually greater, even in the smallest bellows unit, than that of a set of extension tubes, but by virtue of the thickness of the front and rear standards supporting the bellows

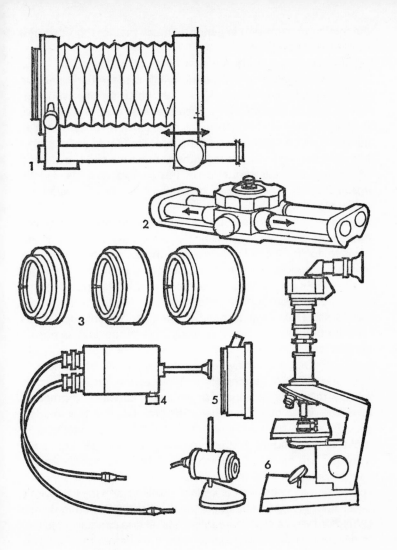

Close-up equipment: **1.** Extension bellows. **2.** Focusing slide. **3.** Extension tubes. **4** Double cable release for use with non-automatic bellows or tubes or with reversed lens. **5.** Auto ring for double cable release. **6.** Microscope and lamp.

the minimum extension is generally much greater than that of a single extension tube.

Broadly speaking, there are two kinds of bellows unit – the cheap and virtually useless and the solidly made rather expensive models which are the only kind with which serious work can be undertaken. Nevertheless, even the least expensive bellows is likely to cost more than a set of extension tubes, but it is generally so flimsily made that the front standard can be pulled out of position by any but the lightest of lenses and the method of locking the rear standard on the camera may be equally unsatisfactory. These types generally have no provision for tripod mounting.

A good bellows needs stoutly constructed standards and smooth runners of reasonable diameter to allow easy movement and positive locks. As this necessarily involves some bulk and weight, a tripod socket is virtually essential to allow the weight of the whole set-up to be reasonably evenly distributed. Many of the better models have tripod sockets in both front and rear standards. They may also have such refinements as scales indicating total extension, reproduction ratios and exposure factors, and provision for the attachment of a slide copying device. Geared tracks may be used instead of smooth runners.

The principles of extension bellows usage are, of course, exactly the same as those for extension tubes. The practice, however, is frequently rather different. Only a few models provide a link between the automatic diaphragm mechanism in the camera and the diaphragm itself in the lens. Without such a link the lens has to be operated manually. If the lens diaphragm cannot be controlled manually, some manufacturers supply a special ring to be placed between the bellows and the lens with a cable-release socket to actuate the diaphragm. Shooting is then carried out with a special double cable release carefully adjusted to ensure that the diaphragm closes down before the shutter is released.

The extension bellows is a useful piece of equipment, but it does take time to set up and those units of adequate quality can be quite expensive. Tubes are generally preferable, unless the extra extension provided by the bellows is expected to be frequently required.

When working at very close range with tubes or bellows, better quality images may be obtained by reversing the lens, i.e. mounting it on the tube or bellows with the front glass facing the camera and the rear toward the object. This is achieved by attaching a reversing ring to the front of the lens. It screws into the filter thread of the lens and has the appropriate camera mount bayonet or thread on the reverse. The reason for this is that all ordinary camera lenses are designed to give their best results when the subject is at a fair distance from the front of the lens and the film quite close to the rear of the lens. In ultra-close work these relative positions are reversed and many lenses do, in fact, give better overall definition when the balance is to some extent restored by reversing the lens.

Here, however, a difficulty arises with automatic diaphragm lenses, even when automatic tubes are used, because the automatic connection is always on the back of the lens. If you wish to retain the automatic facility, or if the lens has no manual diaphragm control, the special ring and double cable release mentioned above have to be used.

Uses of supplementary lenses

The alternative to increasing the camera extension for close-ups is to attach a supplementary lens to the camera lens to alter its focal length. In fact, any positive, or converging, lens attached to the front of a camera lens has the effect of creating a composite lens of shorter focal length. Thus, because the distance between lens and film plane remains the same, it is too great for the lens to focus distant objects, but allows it to focus closer than the camera lens alone. The shorter the focal length of the supplementary lens, the shorter the focal length of the combined lenses and the greater the relative extension.

Actually, supplementary lenses are rarely designated by focal length. Their power is denoted by a dioptre number, and the most popular types are of 1, 2 and 3 dioptres. Dioptre powers and focal lengths are, however, directly related in that the focal length is 1 m divided by the dioptre number. Thus, a 3-dioptre lens has a focal length of about 333 mm. These lenses are

generally simple meniscus types and are not very expensive. They are attached to the lens by means of a filter holder.

The combined focal length of camera lens and supplementary is easily calculated because dioptre strengths can be added. Thus, a standard 50 mm camera lens has a strength of 20 dioptres. With a 3-dioptre lens attached, the combined strength is 23 dioptres and the focal length is 1000/23 mm=43·5 mm. When a camera lens is set to its infinity focusing position and a supplementary lens attached, the focused distance of the combination is equal to the focal length of the supplementary lens. This is easily understandable because the light rays reflected from a point one focal length in front of a lens are bent (refracted) by the lens only to the extent that they emerge as parallel rays. The camera lens set to infinity is, however, set to accept such rays and converge them to meet in the film plane at one focal length behind the camera lens. Thus, a camera lens plus a 3-dioptre lens is accurately focused on a plane about 33·33 cm (13$\frac{1}{4}$ in) from the supplementary lens.

If the camera lens focusing mechanism is used, the focused distance becomes closer still and can be mathematically calculated. The SLR user does not need such calculations. He simply puts the lens in place and views the image on the screen. The advantages of the supplementary lens are its simplicity, its comparative cheapness and the fact that it does not alter the camera extension and thus involves no light losses. Its main disadvantage is that it is inevitably of inferior optical quality to that of the camera lens and will generally have at least a slightly deleterious effect on image quality. Moreover, many standard lenses on 35 mm SLRs can focus down to 45 cm or less without the aid of supplementary lenses, so that higher powers are needed to provide significant advantages.

Camera lens as supplementary

Higher-powered supplementary lenses are, indeed, available but they tend to be rather expensive because of the difficulty of adequately correcting the aberrations in what is really a quite simple lens construction. It does not take much thought to

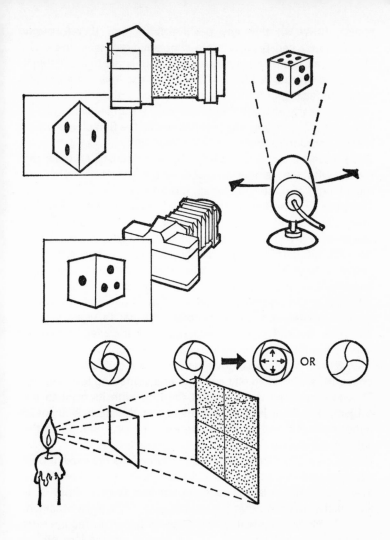

Close-ups. A very close viewpoint can lead to unnatural perspective effects. Using a longer-focus lens on a bellows unit can reduce this effect by increasing the shooting distance. The normally indicated exposure has to be increased because the light has to travel farther from lens to film. If this distance is doubled (for 1 : 1 reproduction) illumination of the film falls to one quarter.

realise, however, that any positive lens (and therefore any camera lens) can be used as a supplementary lens. We have seen that a 50 mm lens is a 20-dioptre supplementary and that it can focus objects at 50 mm (2 in) from the lens. As a camera lens, it is also much more highly corrected than the ordinary supplementary lens. So, if you put two 50 mm lenses together, you have a 25 mm lens placed 50 mm from the film plane, which is the condition required for 1:1 photography.

The supplementary lens, however, always focuses on the same plane (with the camera lens at infinity), no matter what the focal length of the lens to which it is attached.

The focal length of the camera lens, however, does affect the angle of view and therefore the image size. Thus, a 50 mm lens attached to a 135 mm lens, provides an image 2·7 times larger than the 50 plus 50 combination, because image size is in direct proportion to focal length. This combination therefore gives you an image nearly three times life size.

The 135 plus 50 mm lens combination is generally the most suitable. Other combinations commonly cause vignetting. A 28 mm lens used as a supplementary, for instance, would be much more powerful, being the equivalent of about a 37-dioptre lens. The 28 mm lens is, however, often of retrofocus construction, with a very small rear element, and vignetting is inevitable. This can be cured if you mount the lens with its front to the subject, but there is a chance then that the front element is rather recessed and that you cannot get close enough to the subject.

It is generally preferable to use the 50 mm lens reversed, if only because coupling rings with double male filter threads are available to allow lenses to be connected front to front. It is also likely, however, that better image quality will be obtained. The 50 mm 'supplementary' lens should be set to full aperture and the exposure controlled by the aperture of the lens on the camera. The maximum usable aperture may not be as great as that engraved on the camera lens because it depends on the size of the 'supplementary'. The actual maximum aperture can be roughly calculated by multiplying the appropriate f-number on the 'supplementary' by the ratio of the focal length of the camera lens to that of the supplementary. Thus, if a 50 mm f2

lens is used on a 135 mm lens, the maximum usable setting on the 135 mm aperture scale is about 2.7×2, or $f5.6$. This is calculated on the basis (admittedly rough) that, f-number for f-number, the physical size of the aperture on a 135 mm lens is 2.7 times greater than that of the 50 mm lens. This affects only the *maximum* aperture. The remaining f-numbers on the camera lens are accurate and can be used for exposure calculations in the normal way.

When, however, you control the exposure by using the diaphragm of the 'supplementary' lens, *all* its f-numbers should be recalculated in this way (unless you use two lenses of the same focal length) because the aperture sizes are related to the focal length of the supplementary and not to that of the camera lens. Thus, *all* the f-numbers of a 50 mm lens used on a 135 mm lens, for example, should be multiplied by the same factor of 2.7, which is, near enough, a difference of three stops. The $f2$, 2.8, 4 markings on the 50 mm lens, therefore, should be treated as $f5.6$, 8 and 11 respectively. In practice, if an ordinary meter reading indicates an aperture of $f16$, the 50 mm lens has to be set to $f5.6$.

The size of the aperture also affects depth of field and calculations can become very complicated when the diaphragm of the 50 mm lens is used. Fortunately, however, the question is largely academic. Depth of field at very close range is almost incalculable and depends on so many unpredictable factors that it should be regarded as non-existent. When photographing at 3:1, you should assume that you will obtain true sharpness only in a single plane. At best, depth of field cannot be more than about 1/50 in or $\frac{1}{2}$ mm. If you have to photograph an object of any depth, you must shoot from farther away with a different set-up and be satisfied with less magnification on the film.

Macro lenses

A limited amount of close focusing is allowed by so-called macro lenses and zoom or long-focus lenses with a macro facility. The macro lens is generally a 50–55 mm or occasionally

a 100 mm that has extra extension built in, often with an additional focusing scale. It can provide images up to about one-third life size and focuses right through to infinity. Sometimes, an extension tube is supplied with the lens to provide 1:1 reproduction.

The zoom or long-focus types are generally of modest focal length — up to about 200 mm — and have a switch or other device to rearrange the lens elements to provide extra close focusing. Again, the maximum image size is generally about one-third life size. With this type of lens, focusing is not continuous. It has to be switched from normal to macro mode and there may be a gap between the normal closest focus and the beginning of the macro range. Nevertheless, the facility is useful in the field, where the occasional close-range shot may not justify the carrying of close-up equipment.

Problems of close-range work

A further difficulty with close-range photography of three-dimensional objects is that perspective distortion inevitably results. Parts of the subject nearer to the lens (even when the subject has hardly any depth) are reproduced much larger than parts farther away. Recognisable shapes are therefore easily seen to be distorted. The only solution, again, is to shoot from farther away, but, in this case, the use of a longer focus lens may enable you to retain the same image size.

Yet again, if you approach your subject to within a few inches, lighting can become extremely difficult, particularly if you want flat or frontal lighting. Only indirect lighting is, in fact, possible, and you may have to arrange to bounce the light from above or below the camera with the light source carefully shielded from the camera lens. Diffused daylight often provides the answer, but, even then, camera and subject have to be carefully arranged, generally in a horizontal rather than vertical set-up.

Side lighting can be organised without too much difficulty, but the light source is generally too large and has to be fitted with a snoot or open-ended cone to direct the light on to the subject and keep it off the lens. A slide projector can sometimes provide

a suitable light source and more elaborate methods can even involve the use of a condenser lens to focus a narrow beam of light on to the subject.

Focusing the close-up subject is, of course, critical, and it is often advisable to focus at shooting aperture to avoid any possible focus change on stopping down. If the light you intend to shoot by is not very strong, you may not be able to see the screen image very clearly with the lens stopped down; but a pocket flashlamp, projector or other small light source can usually be directed on to the object from very close range to pick out enough detail to focus on. Be careful, however, that it picks out detail in the correct plane. Remember that depth of field barely exists and you must focus exactly on the part you wish to reproduce sharply.

Exposure is rather tricky. The ordinary meter has far too wide an acceptance angle to be used satisfactorily for a direct reading, so it is preferable to take a reading from a standard grey card or any other surface of a similar mid-tone placed in the same lighting as the subject. Alternatively, you can use a matt white surface and multiply the indicated exposure by 5. This works on the principle that the standard mid-tone reflects about 18% of the light falling on it, while a good matt white surface reflects about 90%.

If you are using tubes or bellows, the indicated exposure has to be further increased by the appropriate factor to allow for the increased light path (see page 120). If you use supplementary lenses the meter reading is generally accurate, subject to the limitations indicated on page 128 when you use a camera lens as a supplementary.

None of these calculations need worry you, of course, if you have a through-the-lens meter, which automatically takes care of both increased light path and the effect, if any, of supplementary lenses. It does not, however, take care of the nature of the subject, and you would still be well advised to use the grey or white card method mentioned above. In copying, for example, the meter can be led badly astray if the item to be copied has a predominance of light or dark tones. If, for example, it consists of a relatively small amount of printing on white paper, the meter is likely to read much too high and indicate a

short exposure that will not produce sufficient contrast in the negative to allow a clean print to be made.

Setting up the camera for close-up work can take some time. A tripod is nearly always essential and focusing is critical (see page 121). The tripod must be rock-steady, because close-ups must be absolutely pin-sharp and, as longish exposures are common, it takes only the slightest tremor to destroy definition of fine detail completely.

A cable release must be used and it *must* be held slackly so that it cannot transmit hand tremors to the camera. The only alternative (quite a good one) is to use the delayed-action shutter release mechanism available on some cameras. This allows possible tremors to die down before the shutter is released. It is worth experimenting with the operation of the delayed-action mechanism with the shutter set on B. This frequently gives an exposure of a few seconds and can be useful in close-up work. Use of the delayed-action mechanism, however, does not solve the problem of possible camera tremors caused by the action of the mirror. In some cameras, it is possible to lock the mirror up just prior to releasing the shutter. In others, the actions of lens stopping-down, mirror movement and shutter release are sufficiently well spaced through the shutter release travel to allow you to hold the cable-release button after the mirror has flipped up and to release the shutter a second or two later.

In copying work, it is essential that the copy and film plane be exactly parallel. This can often be satisfactorily achieved by lining up the edges of the copy with the edges of the screen. If that is not possible, a large set-square on the copy and a spirit-level on the camera top can serve for horizontal set-ups or a spirit-level on camera back and copy for vertical arrangements. Occasionally, it may be possible to place a small mirror in the centre of the copy. When the camera lens can then be seen in the centre of the viewfinder, camera back and copy should be parallel. If you focus the image for this check, remember to refocus on the copy. The mirror image distance is greater.

Lighting flat copy is not difficult. Two lamps are sufficient in most cases, set up equidistant from the centre of the copy and at 45° to avoid reflections into the lens. If the item to be copied is large (larger than about postcard size) the lighting arrange-

ment is critical, because with lamps set fairly close to the copy the fall-off in illumination across the surface can be noticeable. Smaller items can frequently be lit quite evenly with one lamp at a distance of a foot or two.

The lamps need not be powerful. Photofloods give enough light for short exposures to be made, but this is not generally important and low-power lamps can be used quite successfully without the extreme heat generated by photofloods.

Flashlighting is convenient for some work, and is particularly handy for copying if two heads of equal power are available. For flat frontal illumination, a ring flash round the lens is invaluable, provided the item to be copied is not on glossy material. If it is, the reflection of the flash is thrown straight back into the lens, practically obscuring the image.

Outdoors, too, for close-ups of flowers and other plant life, a small flashgun can simulate sunlight in the shady corners where the most interesting specimens are often found. Frequently, too, the rapid fall-off in power of the light can separate the subject from its background very effectively. Flash also facilitates short exposures, which may be necessary if the subject is easily moved by air currents.

Close-up photography can be quite fascinating. Apart from its normal applications of photographing innumerable small objects on a large scale, it can form the starting point of various picture-making techniques.

The most mundane objects can be photographed for their pattern or texture and the negative subsequently printed on to high-contrast material to emphasise these aspects alone. Puzzle pictures can be created by photographing parts of common place objects in such extreme close-up that they are almost unrecognisable, such as toothbrush bristles, the ball of a ballpoint pen, the head of a pin, crystals of sugar, and so on.

Close-up pictures can often provide startling wall decorations (rather than pictures), such as an enormous enlargment of an eye (human or otherwise), or part of an engraving, or a postage stamp or even an interesting label or other printed matter.

Flash
Equipment
and Operation

All 35 mm SLRs have electrical contacts connected to the camera shutter in such a way that flashbulbs or electronic flash can be fired in synchronism with the opening of the shutter. The shutter is said to be flash synchronised.

Synchronisation of focal-plane shutters

Most 35 mm SLRs have focal-plane shutters (see page 14) and this, unfortunately, raises a few small difficulties. A particular feature of focal-plane shutters is that, at the faster speeds (often from 1/60 sec), they expose the film through a gap between two blinds which is of such dimensions that the whole image area may not be completely uncovered at any point in the exposure. Only at the slower speeds is the gap wide enough to do this.

This means that electronic flash, which is of extremely short duration, can be used only at those shutter speeds during which the film area is completely uncovered. On vertically moving metal shutters and the odd one or two horizontally moving cloth shutters, the fastest possible speed at which electronic flash can be used is about 1/125 sec. The setting is normally denoted on the shutter-speed control by a flash symbol and that speed is commonly about 1/100 sec.

With most cloth, horizontally moving shutters, the fastest possible speed for electronic flash is much less, commonly 1/30 sec.

The position is slightly different with flashbulbs because they burn for a comparatively long time and, moreover, they need time to build up to their peak intensity. Ideally, therefore, bulbs and electronic flash need different types of synchronisation – one for electronic flash, firing the flash immediately the first blind uncovers the film; and the other, for bulbs, firing the flash *just before* the first blind completely uncovers the film, so that the bulb has time to build up a usable power before the film is fully uncovered.

In a sense, it is unfortunate that there is yet another possibility – that the flashbulb can be kept burning throughout the time that it takes both blinds to move across the film. Then, even the

The outdoor portrait in sunlight benefits from a back-to-the-sun treatment with flash or other fill-in from the front. Be careful not to overdo the fill lighting – *Michael Barrington-Martin.*

Exposure was for the sunlit buildings in the background, leaving the foreground tree to go into near silhouette – *P. C. Poynter.*

Opposite, top: The idyllic scene of the calendar or picture postcard, carefully composed and shot when the animals fitted in with the composition – *E. W. Tattersall.*

Opposite, bottom: With the sun streaming through rather meagre foliage, exposure had to be carefully judged so as not to kill the effect – *P. C. Poynter.*

Opposite: Panning the camera blurs the background and increases the impression of speed – *Klaus Kempin.*

Page 142: A carefully arranged group shot through glass in an open-ended nesting box – *Colour Library International.*

Page 143: It is not unusual for a cat to lick its nose, but a photograph of the tongue in that position is a rarity – *Michael Barrington-Martin.*

Fire is a natural for colour. No black-and-white picture can so effectively convey the heat of the flames and the density of the smoke – *Klaus Kempin.*

Opposite: The very long-focus lens is invaluable at the racetrack, even though it does give a false perspective effect – *Klaus Kempin.*

The frank stare of a child has an arresting effect, no matter how jumbled the surroundings – *Robert Matthias.*

Pages 146, 147: Pleasing colour combinations can be found in the most unlikely places – even after the market has closed or in the stores yard, where a shed window proved fascinating for the photographer – *P. C. Poynter, Robert Matthias.*

Below and opposite: Colour can be monochrome, or almost so. It still adds a dimension to the simple subject, carefully composed at close range – *Klaus Kempin, Anima Berten.*

Page 150: The portrait, double exposed on the darker image of the tower, burns through the tower detail but is unable to print on the already heavily exposed sky area – *P. C. Poynter.*

Page 151: Double exposures on transparency film are not easy, but sandwiching two or more slides together can give a similar effect – *P. C. Poynter, Michael Barrington-Martin.*

Page 152: The sailing boat shot from close range looks more impressive than if a long-focus lens is allowed to flatten the perspective and bring the horizon higher up the frame – *Becken.*

faster speeds can be used. Such flashbulbs are, in fact, made. They are known as focal plane bulbs and they have a longer than usual peak which allows them to be used with focal-plane shutters at any speed.

These focal plane bulbs are, however, very expensive and are not always easily obtainable. Moreover, many camera manufacturers have ceased to cater for them by providing only X-synchronisation via a single socket or contact. Where two connections are supplied, the second — generally labelled F or FP — is probably for focal plane bulbs, but you must check your instruction book to be sure. On some cameras, the synchronisation is variable on a single contact, either by switch or, occasionally, by the actual shutter speed setting. With the ever-growing popularity of electronic flash, however, the SLR owner rarely uses bulbs and many cameras now have just one flash contact both for bulbs and electronic flash intended to be used at the fastest 'fully open' speed for electronic flash and at a slower speed for bulbs to ensure that the movement of the second blind does not cut into the build-up time. The actual speeds to be used must be obtained from the instruction manual for the camera, but they are often indicated on the shutter control by symbols.

Flash contacts now take one of two forms. They are either standard 3 mm coaxial sockets for flash equipment with a two-lead cable terminating in a 3 mm coaxial plug, or flat contacts in the camera accessory shoe for flash equipment with no connecting cable but electrical contacts in the base. Adaptors are available to allow coaxial plugs to be connected to accessory shoe contacts and for base contacts to be connected to coaxial sockets.

Operation of flashbulb equipment

Flashbulb equipment is generally simple. The flashbulb itself is a small glass envelope containing oxygen and inflammable metal wire. Two high-resistance electrical wires leading out of the bulb are connected to a priming paste at their inner ends and to the cap connections, if any, at the outer ends. Only the larger bulbs now have bayonet or screw caps. The smaller

ZIRCONIUM.

types have bare wires formed in such a way that the bulb can be pushed in to a simple spring-loaded socket.

The bulb is fired when an electrical current is fed through the wires. The high-resistance wires become hot enough to ignite the priming paste which, in turn, ignites the inflammable filling. The oxygen ensures a brilliant, clean light of short duration.

The voltage needed to fire the bulb is not critical and early units contained only the bulb and one or two $1\frac{1}{2}$-volt batteries. The connecting wires offered such a high resistance to the current, however, that firing became unreliable as the batteries weakened and most units now use a capacitor. This is an electrical storage unit which extracts electricity from the battery and builds it up to its own rated capacity, regardless of the state of the battery. The flashgun contacts are connected across the capacitor, so that its energy can be released through the bulb as soon as the switch is closed by the operation of the shutter release. The circuit is simple and reliable, even when the battery is nearing the end of its life.

Flashbulbs come in various sizes, but the AG1 type is now almost standard. This is a very small bulb designed to be used in quite tiny lightweight flashguns, with reflectors often no more than 2 in in diameter. The reflector – a shiny, generally dished surface behind the bulb is essential to ensure that the maximum amount of light is thrown forward on to the subject. The wrong type of reflector – too small, too large, wrong shape, etc – can considerably reduce the effective light output. The only type of bulb that offers no reflector problems is the flash cube – an arrangement of four bulbs in a cube container with its own reflectors and designed to be used on a rotating mount for quick-firing sequences.

Despite its size the AG1 bulb is remarkably powerful, requiring relatively small apertures to be used at any distance under 8–10 ft (see page 159). It is now always blue-coated to simulate daylight, owing to the widespread use of daylight-balanced colour film (see page 50), and is therefore known as the AG1B. A slightly larger bulb is the No 1, or PF1, type that was previously the most popular. It, too, is always blue-coated, but uses a different kind of socket and cannot be fitted into flashguns designed only to take AG1 bulbs. Most units are designed,

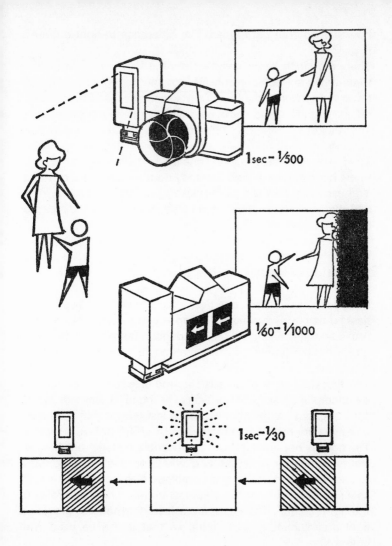

1sec – 1/500

1/60 – 1/1000

1sec – 1/30

Electronic flash and shutter action. Blade shutters can be used with electronic flash at any speed. Focal plane shutters expose only part of the film at a given moment at higher shutter speeds. At 1/30 sec and slower (1/100 sec on some cameras) the flash can be caught while the film is fully exposed.

155

however, to take both types. The difference in light output is negligible.

There are much larger bulbs – from the PF5, which has about three times the power of the PF1, to the PF100, at four or five times the power of the PF5. These, naturally, need much larger reflectors and base contacts, but their uses are highly specialised. The AG1 or PF1 are more often too powerful than not powerful enough.

The flashbulb is expendable – one bulb, one flash – so the small bulbs have the advantage that they do not take up much room. You can carry 40–50 in your pockets without much discomfort and the flashgun itself may need little more space than a packet of cigarettes.

Operation of electronic flash

If the idea of one bulb, one flash does not appeal to you – and flashbulbs are by no means cheap – you may find it better to use electronic flash, which, although intended for the same purpose, is a totally different method of obtaining a brilliant flash of light.

The first difference of note is that the electronic flash is more genuinely a flash. The ordinary flashbulb burns for about 1/50 sec, but few electronic flashes last longer than 1/300 sec and most are probably in the region of 1/500 to 1/800 sec.

The light is not created from combustible material but from an electrical discharge across two wires, or electrodes, inside a sealed tube filled with a gas or mixture of gases that acts both as a sort of switch for the electrical current and a controller of the light 'colour'. The gases are selected, in fact, to provide a light approximating to daylight, so that it can be used with colour film.

The circuitry of the electronic flashgun is much more complicated than that of the bulb unit. It uses a low-voltage battery and a capacitor in the same manner, but the flash tube needs a considerably higher voltage than a bulb. The 'smooth' current (DC) from the battery, therefore, has to go through sub-circuits to convert it to a pulsating current suitable for passing through

Flash equipment: 1, Electronic flash with "hot shoe" contact. 2, Bulb gun with cable connection. 3, Accessory shoe contact for "hot shoe" equipment. 4, Converter to fit "hot shoe" equipment to camera socket. 5, Converter to fit cable connector to accessory shoe contact. 6, Large electronic flash with extension heads.

a step-up transformer and then to convert the subsequent high-voltage current back to the DC required, to charge the capacitor or capacitors. The capacitors are now generally connected directly across the flash tube, but cannot discharge through the gas until it is electrically charged (ionised) by a separate very high-voltage pulse of electricity usually supplied by a third electrode encircling the outside of the tube and connected to a triggering circuit. As soon as the triggering pulse is applied to the tube (by closing the switch across the flash leads – the camera contacts or a separate button switch) the gases ionise and the capacitors discharge instantaneously across the electrodes. The gases then return to their normal state, while the capacitors recharge, and further flashes are barred until the triggering pulse is again applied.

The capacitors are generally of very high power and take a significant time to recharge fully, depending on the construction of the particular unit. This is known as the recycling time, and its conclusion is indicated by an audible or visible signal, generally the lighting-up of a small neon lamp which can be set to 'strike' at a specific voltage. When the neon lights the flash can be fired again. If you fire it before the neon lights, you either get no flash at all or a flash of reduced brilliance, because the voltage applied to the tube is lower than it should be. It is advisable, in fact, to wait a few seconds longer than it takes the neon to light, because it is common practice to set the neon to strike when the capacitors are about 80% charged. There are no reflector problems with electronic flash because these units invariably have their own built-in reflector designed specifically for the tube size and shape, which may be straight, coiled, circular, U-shaped, etc.

There is an enormous variety of sizes of electronic flash units, from quite small, easily pocketable models to massive studio equipment mounted on wheeled carriers. The greater the light output, the larger the power pack (batteries and capacitors take up the most space) you need to fire the tube and, generally speaking, the smallest units (those made in the greatest numbers) are of very low power. The smaller flashbulb is much more powerful.

Electronic flash must always be used from the X-synchronisation

socket on the camera. If there is only one socket or connection, it is now invariably X-synchronised. If there are two sockets, the other (marked F, FP or, rarely, M) makes contact fractionally before the first blind reaches the end of its travel and the instantaneous electronic flash therefore would occur while part of the film is still covered if this were used.

Guide numbers for flash exposures

The power of flashbulbs and electronic flash units is (except with large studio units) indicated by the guide number system. The watt-second or joule rating sometimes quoted for electronic flash is a purely mathematical calculation and is of little value for indicating the power of the light for exposure purposes.

The guide number system relies on the fact that light rays from most sources diverge and so cover a larger area at a greater distance. The larger the area covered, the less the strength of the light falling on a given part. This follows, more or less, the inverse square law, which says that in such circumstances the strength of the light is in inverse proportion to the squares of the distances. Thus, if a light source is moved from 2 m to 8 m, the relative strengths are $8^2:2^2$ or 16:1. At 8 m the light has only one-sixteenth the power of the same light at 2 m.

The f-numbers engraved on lenses work in the same way. At $f2$ and $f8$, the relative amounts of light reaching the film are also 16:1. At $f8$ only one-sixteenth as much light reaches the film as at $f2$. It is evident, then, that for any light source the same amount of light reaches the film when the light is 8 m from the subject and the lens set to $f2$ as when the lens is set to $f8$ and the light is 2 m from the subject.

Thus, if at these settings the film were correctly exposed, it could be said that the light source had an exposure guide number of 16 and any combination of lamp distance and aperture that, multiplied together, gave 16 would also give correct exposure, such as $f4$ and 4 m, $f16$ and 1 m, and so on. If the lamp is stronger, the guide number is greater.

Guide numbers are related, of course, to the unit of measurement. If you measure your distances in feet your guide number

is correspondingly larger. Most bulb packings and electronic flash units carry both feet and metre guide numbers.

Two other factors affect the guide numbers for *flashbulbs* – the speed of the film used and the shutter speed. Naturally, if the film is twice as fast, it needs only half as much light. The guide number is therefore larger to indicate a smaller aperture at a given lamp distance. The guide number is not doubled, however, because doubling the guide number would result in doubling the *f*-number, which means that the light transmission is reduced to one-quarter, not one-half. So, for a doubling of film speed, requiring only one-half as much light, the guide number is multiplied by the square root of 2, which is 1·4. This does not generally have to be calculated, however, because separate guide numbers for each film speed are quoted on flashbulb packets and electronic units usually carry similar figures or an exposure calculator.

The effect of the shutter speed does not so often concern the SLR user because most SLR cameras have focal-plane shutters that cannot be used at faster speeds with flashbulbs. When flashbulbs are used at faster speeds with blade shutters, however, the synchronisation is such that the faster the shutter speed the smaller the amount of the flash that is used. The normal flashbulb takes about 1/50 sec to emit all its useful light. At shutter speeds slower than 1/50 sec, therefore, all the flash is used. At 1/250 sec the shutter is open only from just before to just after the peak and the effect is to reduce the amount of light transmitted to the film to about one-quarter of the full output of the bulb. So, at 1/250 sec, the guide number is halved. This does not apply to electronic flash, which is rarely significantly longer in duration than 1/1000 sec. Again, however, the range of focal-plane shutter speeds with which electronic flash can be used is restricted, the maximum speed ranging from 1/30 sec to about 1/100.

The general practice, therefore, in calculating the exposure for flash pictures with a focal plane SLR is to ignore the shutter speed. You simply check the guide number for the speed of the film you are using and divide it by the distance from the flash unit to the subject to obtain the aperture to which you must set the lens. If the guide number (feet), for example, is 48 and

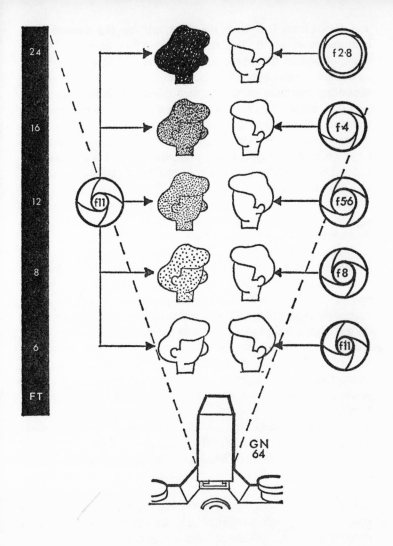

Flash exposures. The guide number is the product of aperture **(right)** and flash distance **(left)**. Thus, at 6ft an aperture of *f*11 is required for guide number 64. At 16ft, *f*4 is necessary. If the same aperture were used for all distances, the subject at 6ft would be considerably over-exposed and that at 24ft drastically under-exposed.

161

you shoot from 6 ft *with the flash unit on the camera*, your aperture must be *f*8. The shutter speed has no effect, but it must, of course, be appropriate to the type of flash being used, as quoted in your instruction book.

Mounting the flash on the camera does not, in fact, generally give very satisfactory results. It lights the subject flatly from the front and can destroy any sense of form or shape. It is often better to use an extension flash cable to enable you to place the flash a little to one side. Remember, then, that it is the flash-to-subject distance that you use for exposure calculations, not the shooting distance.

Automatic exposure control

Guide numbers offer a method of comparing the powers of different flash units but in practice they are obsolescent in low power electronic units. Many such units are of the so-called computer type containing a light sensor which measures the light reflected from the subject and extinguishes the flash when it calculates that sufficient has been reflected to indicate correct exposure. Generally, three settings are provided. Two allow alternative aperture settings to be used according to film speed, while the other allows manual operation with the automatic facility switched off.

The apertures usable vary with the film speed, as do the maximum distances at which the flash will work satisfactorily. With a guide number (feet) of 54, for example, and choice of either *f*5.6 or *f*11, you have maximum flash-to-subject distances of about 11 ft and 6 ft.

Automatic flash systems are also built into various cameras via contacts in the accessory shoe and the foot of the flash unit. In conjunction with electronic shutters and fast-acting sensors, these units can set the shutter speed automatically and meter the flash through the lens.

Many auto flash units have the disadvantage, however, that they must be used on the camera, sometimes because the sensor is in a fixed position in the unit and sometimes because contact must be made through the 'hot shoe' with the flashgun circuitry. Some

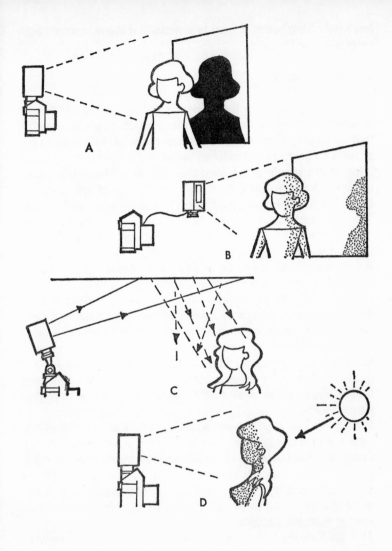

Using flash: **a,** Flash on camera gives flat lighting and shadow on background. **b,** Flash off camera can provide modelling and separate shadow. **c,** Bounced lighting gives soft effect. **d,** Flash in sunlight relieves deep shadows.

have swivelling heads or remote sensors that allow bounce flash techniques to be used.

Adding fill light

A flash unit placed on the camera may produce rather heavy shadows that are not suited to the subject. You can remedy that by placing a reflector on the other side of the camera axis at such an angle that it catches some of the light and redirects it into those shadows to lessen their intensity. The reflector can be any suitable surface, such as a large sheet of white paper, crumpled metal foil on hardboard, a nearby wall, and so on. The only restriction is that, in the case of colour film, the reflector must be neutral coloured or it will reflect coloured light on to the subject.

Alternatively, you can use another light source, such as an extension head to your flashgun, if possible, another flashgun linked to the camera contacts via a Y-junction, a slave unit (a flash unit with a sensor that picks up the main flash and fires its own flash independently), or even a tungsten lamp with black-and-white film. You must not use tungsten lamps and flash together on colour film because their characteristics are different. The flash approximates daylight, but the tungsten lamp is much yellower and puts a yellow cast on the daylight-balanced film.

In all three cases, you must remember that the function of the reflector or secondary light is to lighten the shadows, not to obliterate them. It must be much weaker than the main light, generally not more than one-quarter of its power. If the secondary light is another flash unit or extension head of the same power as the main light, it should therefore be twice as distant from the subject.

This fill-in light is generally best placed near the camera to avoid the cross-lighting effect of lamps on either side of the subject. It thus adds some light to that provided by the main light, but, as its function is to reduce contrast and as its power is so relatively low, it should be disregarded in exposure calculations.

Another effective method of softening the shadows is to

'bounce' the flash so that the light reaches the subject indirectly from a large reflecting surface such as a wall or ceiling – or both. Again, these surfaces must not be coloured when you use colour film. A popular method is to use a white umbrella (there are various commercial versions) as the reflecting surface. This is placed in front of the subject and the flash placed so as to fire into it and throw the light back on to the subject. The result is a reasonably even flood of light that forms only very light shadows and is particularly suitable for colour film.

Whatever the bounce method used, the exposure calculation must allow for the full distance from flash to subject, which is the sum of the flash to reflector and reflector to subject distances.

Combining flash and daylight

Flash can be used in conjunction with daylight, and sometimes even as a substitute for direct sunlight. Unfortunately, this function is somewhat limited with most 35 mm SLRs because of the drawbacks of the focal-plane shutter. Sometimes, for example, pictures taken outdoors in bright sunlight, particularly of people, contain harsh shadows that could be very effectively lightened by using a relatively weak flash from the camera position. If, however, your camera can only synchronise flash at 1/30 sec, it is likely that you will not be able to set a small enough aperture to prevent the daylight causing overexposure. Similarly, if there is movement in the subject, even if you can set a small enough aperture, the movement will be registered by the daylight during the relatively long exposure. The result is a sharp image plus a blur effect. As mentioned earlier, some cameras can synchronise electronic flash at about 1/100–1/125 sec, so these models offer greater flexibility in the use of flash with daylight.

The power needed from the flash for fill-in is generally about one-quarter of that required for a full flash exposure. If you have one of the very small pocketable flashguns, that may be easy to arrange. If the daylight and shutter speed used call for an aperture of $f8$, for example, and you are shooting from 6 ft, a small flashgun with a guide number of 24 for the film in use

will be just right, because, to obtain one-quarter of normal power, you can double the guide number.

When the flash unit is too powerful, other methods of reducing the power have to be found. If, in the circumstances above, the flash unit has a guide number of 60, it needs to be placed 20 ft from the subject to give one-quarter of the normal exposure. That is often not practicable and the alternative, therefore, is to obscure the flash in some way to reduce its light output. Some photographers manage to spread two or three fingers in front of the flash head, others use two or three folds of a white handkerchief or a specially prepared diffuser. You can use any method you have tested and found reduces the power of the flash sufficiently to lighten the shadows in a natural-looking manner. If the flash is too powerful, the result is decidedly unnatural.

An automatic flash unit can be used as a fill light in daylight by setting a smaller lens aperture than is recommended for the switch setting, providing, of course, such an aperture is suitable for the daylight conditions and the mandatory shutter speed for the flash when using cameras with focal plane shutters. Otherwise the unit has to be switched to manual operation.

Flash can occasionally serve as a substitute for the sun, when the normal lighting is very dull. The main point to remember in such circumstances is that the flash should be placed fairly high up. The technique is useful with close-ups, especially where snow, frost, dew etc, are involved and there is no sun to add the required sparkle. Exposure depends on the circumstances. Generally, the normal guide number should be followed, but remember that the power of the flash falls off rapidly with increasing distance.

It is advisable, therefore, to keep the flash reasonably distant from the close-up subject to avoid too much darkening of the background. Some compromise may be required if the sky appears in the picture, because the small aperture the flash demands may cause underexposure and unnatural darkening of the sky area. Some attempt must then be made to balance the lighting by diffusing the flash or taking it further away from the subject to allow a larger aperture to be used.

Filters and
Lens
Attachments

All 35 mm black-and-white film in popular use today is panchromatic. That means that the film responds to light of all colours and reproduces each colour reasonably accurately as an appropriate shade of grey. That may seem a superfluous observation to those who do not know that panchromatic film is a comparatively recent invention and that early films were sensitive only to blue light, and later versions mainly to blue and green. However, now that films are sensitive to all colours, it is possible to use filters of all colours.

How filters work

The photographic filter is a coloured material that is placed in front of the lens to absorb light of some other colours and so alter the tonal rendering of the various colours in the picture. The general principle is that a coloured filter absorbs most strongly light farthest removed from it in the spectrum of white light and passes most freely light of its own colour. Probably, the best known example is the yellow filter commonly used to absorb the complementary blue of the sky so that little of it reaches the film, which is correspondingly reproduced rather darker on the final print. This enables white clouds to show more clearly. The effect can be made more noticeable by using a filter nearer the red end of the spectrum, such as orange or red itself. A deep red filter can absorb blue almost completely and so produce black skies.

There are other obvious applications. You may have a scene in which colours are so similar in brightness that they appear in the print as the same shade of grey. That could be remedied by using a filter. This is most often of value in copying. You might have red printing on a green background. A green filter could produce a black on white result. A red filter could make the copy white on black. Similarly, the study of postmarks or similar frankings can be made easier by photographing them through a filter of the same colour as the stamp.

Whenever you use a filter, however, you must remember that few colours are pure. The filter may not have exactly the result expected and it will, in any case, affect other colours in the

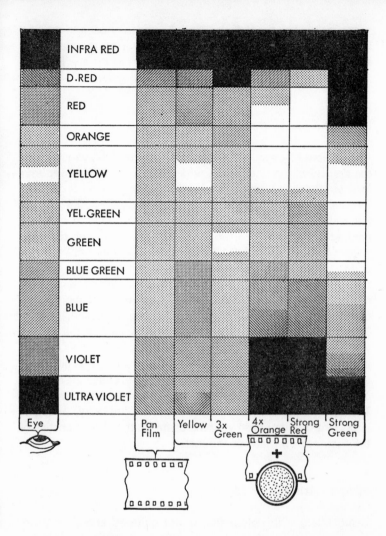

Filter effects. The density of the image produced on panchromatic films by light of various colours varies with the colour of any filter placed over the camera lens. The chart gives an approximation of the darkening or lightening effect on various colours of the most commonly used filters.

scene, as well as those for which it has been chosen to modify. If you use a yellow filter to darken the sky, for example, it will also turn any yellow or cream-coloured part of the scene into a stark white and may lighten some reds and greens.

Effect on exposure

All coloured filters absorb a certain amount of light, varying with the density of the filter. Thus, when you place a filter over your lens, you have to increase the exposure. The increase is denoted by a factor applied to the filter, such as $1\frac{1}{2} \times$ yellow, $2 \times$ orange, $3 \times$ red, etc. Thus, if a normal exposure calculation or meter reading indicates 1/125 sec at f11, the exposure with the $1\frac{1}{2} \times$ yellow filter should be 1/125 sec at f9 (midway between f11 and f8) or, with the $3 \times$ red filter, 1/125 sec at f6.3 (midway between f8 and f5.6). Note that the filter factor denotes a multiplication of the exposure time or amount, not the number of stops by which the exposure should be increased.

These calculations are generally unnecessary when the camera you use has TTL metering facilities, because the meter reading is affected by the filter on the lens. Nevertheless, it is advisable when using the more deeply coloured filters to check the reaction of the meter by taking readings both with and without the filter. The spectral sensitivities of meters and films vary, and it is important that you base your exposure on the characteristics of the film, not on those of the meter.

Filters with colour film

Using filters with colour film is not quite so straightforward. You cannot shoot through a coloured filter without overlaying the colour of the filter on all the colours in the scene and producing what is known as a colour cast. The ordinary yellow filter used in black-and-white photography would turn all highlights in a colour film bright yellow and distort most other colours with a heavy yellow cast. So, correction filters used with colour material are very faintly coloured and their effect

is much more subtle than with black-and-white films. In fact, true correction is rarely undertaken with colour except by specialist photographers in the commercial field, who have particular reasons for requiring the closest possible approach to colour fidelity.

The average photographer rarely uses anything other than a haze or UV filter. The UV — more accurately UV-absorbing — filter is occasionally necessary because the photographic emulsion is sensitive not only to visible light but also to the ultra-violet radiation that is not visible to the human eye. On colour film it can sometimes cause a noticeable blue cast. This happens, however, only where the atmosphere is clean and free from the dust and other minute particles that scatter short-wavelength radiation and prevent it from reaching the earth. These conditions are found at high altitudes and near large tracts of water.

The true UV filter is colourless, but some filters sold under this description have a faint yellow or pink tinge. These would be more accurately described as haze or skylight filters. They absorb both UV and a certain amount of visible blue. They can be useful in reducing the bluishness over distant parts of the scene and the blue cast caused by an excessively blue sky UV and haze filters generally require no increase in exposure.

Colour temperature and conversion filters

The only heavy filtering used with colour film by the average photographer is that concerned with changing the character of the light reaching the film from daylight to artificial light. Most forms of light have a particular characteristic known as colour temperature. This is closely related to the well-known characteristic of heated metal to change colour as its temperature increases, first becoming red and then orange, yellow and white. Colour temperature is, in fact, based on the colours of light that would be emitted by a theoretical perfect radiator of heat, but the principle is the same. At the red end, the colour temperature is lowest. At the blue end it is highest. The unit used

171

is the kelvin, which is numerically the same as the absolute scale of temperature, which, in turn, is the centigrade or Celsius degree figure plus 273.

The importance of the colour temperature concept to colour photography is that colour films can be made to give accurate colour rendering only if the subject illumination is kept within a relatively narrow range of colour temperatures. Naturally, colour film is made for use in daylight, which is generally taken to be about 6000K, but other types are made for working in artificial light.

The so-called Type A film, formerly widely used for photoflood lighting, is now obsolescent and Type B, for the rather yellower studio-type lamps of about 3200K is the only artificial-light film generally available. It can give acceptable results in most forms of reasonably powerful artificial light. If it is used in daylight, a salmon-pink conversion filter is needed to absorb the excess blue and bring the colour temperature down to 3200K.

As with filters for black-and-white film, the salmon-coloured conversion filter makes an exposure increase necessary. The filter absorbs about 40% of normal daylight and the exposure increase amounts to one stop or f-number. If a normal meter reading, for example, indicates 1/125 sec at f11, the exposure should be 1/125 sec at f8 or a fraction smaller. Alternatively, the exposure calculation should be based on an ASA speed 40% lower, i.e. a 100 ASA film should be rated at 64 ASA or a 64 ASA film at 40 ASA, and so on.

This is not a significant reduction in effective film speed, so the use of artificial light film in daylight is feasible. The reverse procedure is rather less practicable because, to expose a daylight film under artificial light, you need to filter out the excess red and yellow in tungsten lighting to produce a balance with the blue that is similar to that of daylight. As there is very little blue in tungsten lighting, the filtering has to be very heavy. The deep blue filter required absorbs, in fact, more than 60% of the light and, as daylight colour films rarely exceed a speed of 64 ASA, the loss of effective film speed makes the use of such a film in artificial light generally impracticable except for photography of static objects brightly lit or when long exposures raise no problems.

Use of polarising screens

A special type of filter that can serve for both black-and-white and colour film is the polarising filter or screen. This makes use of the special properties of polarised light.

Light, like other forms of radiation such as radio waves, moves in a wave motion, the waves radiating in all directions at right-angles to the line of travel. In some circumstances, however, it can become plane polarised, i.e. instead of radiating in all directions, the waves radiate in one plane only (horizontal, vertical, diagonal, etc) still at right-angles to the line of travel. Light can be polarised in this way by passing it through a specially constructed filter that acts like a slotted screen, cutting off all radiations except those in one particular plane, which varies according to the rotation of the filter.

Some shiny surfaces also polarise light that strikes them at a certain angle, generally at about 55° to the normal. Such surfaces are glass, water, heavily polished wood or other material, glazed papers and, in fact, most such surfaces except metal. Thus, if you take a photograph at about 35° to such a surface (which is 55° to the normal), any reflections you pick up from the shiny surface are highly polarised.

The significance of these facts is that, if you can polarise light into a certain plane by rotating a polarising filter in its beam, you can also cut out that polarised light by rotating another filter until its slotted effect is at right-angles to the first filter. Thus, when light is polarised by reflection from a shiny surface, you can place a polarising filter over the lens and rotate it until the reflections, as seen on your reflex screen, disappear, leaving only the random light from the surface or objects behind the shiny surface to affect the film.

Unfortunately, this facility tends to be overrated because the maximum effect can be obtained only when the reflections are fully polarised and that occurs only, as we have said, when the light strikes the shiny surface at about 55° to the normal or perpendicular. This means that reflections can only be totally eliminated when the shooting angle is at about 35° to the offending surface. At any other angle the light is only partially polarised and reflections can be only partially subdued.

Nevertheless, the polarising screen has a useful function in colour photography because light reflected from a clear sky at right-angles to the direction of the sun's rays is frequently polarised to some extent. Thus, by suitably orienting a filter over the camera lens, you can cut out some of the skylight and deepen the blue of the sky.

The polarising screen is neutrally coloured and thus has no effect on other colours in the scene. It has some density, however, and absorbs light quite heavily. The filter factor is about $2\frac{1}{2}\times$ to $4\times$, depending on the characteristics of the individual filter.

Specialised effects are possible when polarising filters are used over both light source and camera lens. The most important of these effects for the photographer is that obtained when copying glossy-surfaced objects or objects under glass by artificial light. If a polarising screen can be placed over the light source, reflections from the glossy surface will be highly polarised and can be controlled by suitable orientation of the filter over the camera lens. In this case, the incident light can come from any angle.

Special-effect screens

Other front-of-lens attachments include soft-focus discs, screens to form star shapes from images of lamps or other light sources, prism-like structures to form multiple images and split-focus lenses.

The soft-focus disc, much less popular than it used to be, is designed to scatter the image-forming rays to a limited extent to take the crisp edge off the definition given by the camera lens. The effect is to soften the edge between different tones and to spread the lighter tones into the darker to give a soft luminous effect that was once thought particularly suitable for portraits of women. The commercially produced disc may have a dot or concentric circle engraved pattern, but a plain glass attachment or UV filter smeared lightly with petroleum jelly can have a similar effect. The degree of softening depends on the density of the patterning and the area it covers. It is common

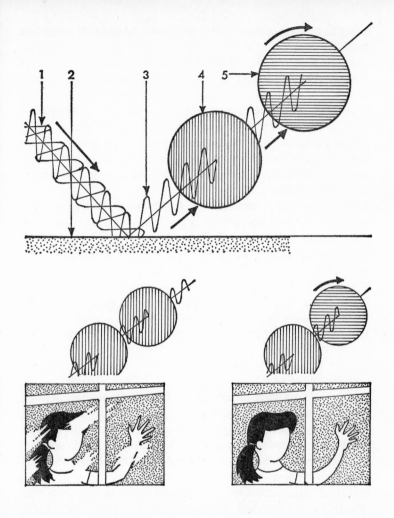

Polarisers. Ordinary light rays (1) vibrate in all directions. After striking some reflecting surfaces (2), the reflected rays (3) are polarised, vibrating in one direction only. A polarising filter can be positioned to pass these rays (4) or to absorb them (5). In the right circumstances, surface reflections can be eliminated so that random light from the subject forms a clear image.

practice to leave a clear area in the centre of the soft-focus disc which allows the effect to be controlled by opening or closing the lens aperture. The SLR user has the great advantage, of course, that he can study the varying effects on his viewing screen.

A variation of this technique is to place such a screen (a sheet of plate glass, perhaps) a few inches in front of the lens and to smear petroleum jelly around its edges, leaving a clear central area. You can then photograph the central part of the subject normally through the clear area while diffusing the corners to any desired effect.

The starred effect imparted to street lamps and other light sources in some photographs is provided by another commercially produced disc that can also be improvised. The effect is becoming a little hackneyed, but it can occasionally add interest to a picture of which the lights form an important part. The improvised version is simply fine-wire mesh. A four-sided mesh gives a four-point effect, five sides give five-pointed stars, and so on.

Various multiple-image lens attachments are available. These are multi-faceted types, each facet forming a separate image on the film. Again, this effect has limited applications and tends to be used for no apparent reason.

The split-focus lens is virtually half a supplementary lens to provide both close-up and distant focusing in the same picture. The intention, of course, is to extend the depth of field far beyond that normally attainable. Half of the attachment lens enables you to focus an object only a foot or so from the lens, while the camera lens itself is focused through the clear glass half on a greater distance. The snag is that the supplementary lens part gives very little depth of field and there is inevitably an unsharp zone between the far limit of the supplementary lens and the near limit of the camera lens. If you have a picture in mind where such an unsharp zone is unimportant or can be concealed, this is the attachment for you.

Most of these attachments are specifically designed for the SLR user because he can see the effect on his screen and adjust it to his requirements before making the exposure. That is a point always worth remembering when you are looking for

special effects. No matter what you place in front of your lens, the screen will give a clear image of the effect obtained. You can use masks to give stylised keyhole, binocular, telescope, etc, effects. A sheet of plate glass a foot or so in front of the lens can carry out of focus shapes that are particularly effective in colour to complement certain subjects. If the glass is suitably angled, it can pick up a reflection of a brightly lit subject to the side of the camera and combine it with the scene shot through the glass. The possibilities are endless.

Accessories
for the SLR

The single-lens reflex design lends itself to a host of accessories. Some of these we have already mentioned, such as additional lenses, close-up equipment, filters, exposure meters, etc. There are innumerable other specialised items of equipment.

Colour-slide copying

In the close-up field, a common item of additional equipment is a slide copier. The one major disadvantage of the colour slide is that it is a positive image formed on the film used in the camera. Whereas a negative can easily provide any number of positive prints, the colour slide has to be rephotographed to be duplicated.

There are two kinds of slide copier. One consists of a tube housing a small, fixed-focus lens held at the 1:1 distance from a transparency holder. Some forms have a built-in zooming facility to allow copying at up to 2:1.

The other type is designed to be attached to extension bellows units designed for the purpose. The bellows is set to provide double extension (for 1:1 reproduction) and the copier is attached to the front, according to the instructions for the particular model.

Either type, which has a diffuser behind the transparency, can be used by pointing the entire equipment to the sky to illuminate the slide, but a more satisfactory arrangement is to illuminate the diffuser by an electronic flash unit placed at a distance found suitable by practical experiment.

It is generally preferable with this type of equipment to shade the transparency from incident light. This can be achieved either by completely enclosing the space between lens and slide holder or by deeply hooding the holder.

The slide copier can provide duplicate slides, colour negatives, black-and-white negatives or black-and-white slides, depending on the film material in the camera. Exposure depends on the usual factors of light source, shutter speed, lens aperture, and so on. The advantage of electronic flash is that you can easily establish a standard exposure for slides of normal density. When the density of the slide varies from the normal, you may

have to vary the copying exposure. This does not always follow, however, because the deviation from the norm may be due to over or underexposure of the original, and you may, in copying, be able to correct that error.

You can, of course, use filters in copying – possibly to correct a colour bias in the original. The filter can be a colour correction type for attaching to the camera or you may be able to use cruder materials, such as coloured foils or gelatins (colour printing filters are suitable) behind the slide. More strongly coloured foils or filters can provide special effects.

Microscope attachments

Photomicrography is too highly specialised a field of photography to describe all the processes in detail here. Again, however, the SLR is particularly suitable for this type of work. Any microscope and any SLR camera can be used.

The simplest method is to focus the microscope in the normal way and attach the camera (with its lens focused on infinity) to the eyepiece. This, however, is rather a waste of the reflex focusing facilities of the SLR. The method used by the serious worker is to remove the eyepiece from the microscope and to attach the camera body to the drawtube of the microscope with a special attachment supplied by the camera manufacturer. This attachment naturally forms a light-tight join between camera and microscope, so that the microscope objective acts as a camera lens on a long extension.

Depending on the quality of the microscope and the suitability of its objective, excellent work can be carried out in this way, and, indeed, this is the very method by which a great deal of first-class photomicrography is achieved. The normal focusing screen, however, is likely to be rather too coarse for really fine focusing and the user of an SLR with interchangeable screen facilities has an advantage because he can generally obtain special screens for the purpose.

Most modern microscopes are suitable for photomicrography and many of their manufacturers supply special accessories for this purpose together with full explanatory literature.

Attachments for stereoscopy

Our two eyes give us an advantage over the camera. They give us two separate views of everything we look at and, as our eyes are about 65 mm (2½ in) apart, the two views have distinct differences. Each eye, for example, sees past an object in a different way. To the left eye, something behind the nearer object may be partially or totally obscured, while to the right eye it is clearly visible. A box slightly angled to us might show part of its side to one eye, while the other can see only the front and cannot assess its depth. In fact, even the eye that can see the side would not 'know' that it were a side if the apparent slope of its top and/or bottom were not visible. The brain, however, gets both pictures and interprets the fact that one eye can see more than the other at that end of the box as an indication that part of it is in a different plane.

The camera obtains only one picture and cannot give this positive indication of depth. It can imply it, of course — by relative sizes of objects the brain knows to be the same size, by differential focusing showing an object standing out sharply from an unsharp background, by variations in tonal values from dark in the foreground to light in the distant background, and so on. But this is interpretive. It is possible to make the camera provide a much more realistic appearance of depth.

The brain receives its information about the third dimension from the two separate views provided by the eyes. So, if we make the camera take two different photographs, from viewpoints 65 mm apart, and then allow each eye to view simultaneously only the picture taken from its own position (left or right), the brain interprets the pictures presented to it exactly as it does the normal two-eyed view of the scene. Consequently, we 'see' depth in the scene, although we are looking at two-dimensional pictures.

It is quite easy to make a shallow wooden tray into which the camera can be fitted so that, when it is slid to one end, the lens moves 65 mm from its position when the camera is at the other end of the tray. If you take a picture of the same scene with the camera in each of these positions, you have a three-dimensional or stereoscopic pair — provided the scene is

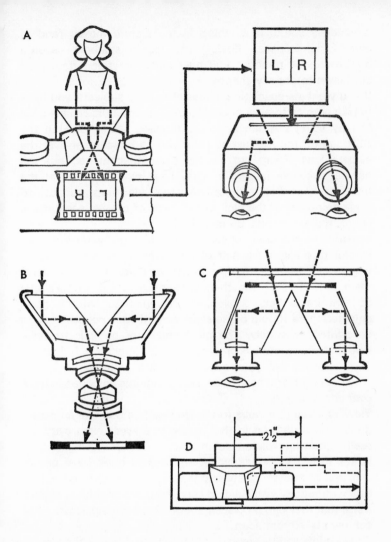

Stereophotography: **a,** An attachment fitted to the camera lens provides two images from slightly different viewpoints on the 35mm frame. The resulting transparency is placed in a viewer which presents one image to each eye. **b,** Construction of attachment. **c,** Construction of viewer. **d,** Stereo pairs of motionless subjects can be taken from two camera viewpoints.

completely static. If anything in the picture moves (and in some circumstances – flower close-ups, for example – even a breeze can be ruinous) you may obtain anything from total confusion to ghostly shapes.

If you want stereoscopic pictures of moving subjects, you have to take both pictures at once. The true stereoscopic camera does this by using two lenses at the required separation, but the SLR can do the job just as well with an attachment over the camera lens. There are various such attachments, but the general principle is similar. They have two apertures at the front, each of which directs an image via mirror surfaces to separate halves of the film. In this case, of course, each image is only half the normal 35 mm picture size.

When you make prints of stereoscopic pictures, you have to be careful to enlarge the pair of negatives to exactly the same degree and the only foolproof way of doing that is to place them in the enlarger together, which makes the pair on a single 35 mm frame very convenient. Nevertheless, with a good enlarger, there should be no serious risk if each negative has to be printed separately. The most important point is to make sure that each picture is presented to the correct eye. It depends on the design of your attachment and your stereo viewer whether or not you have to separate the prints and change them over after printing.

Viewers come in various forms, from simple box-like constructions with a division in the middle to prevent each eye from seeing the other picture to more complex arrangements with lenses to provide enlargement and reduce bulk. Most people can, in fact, train themselves to view 3D pictures placed side by side without any visual aid. Ideally, the prints should be of such a size that they can be placed about 12–13 mm apart with their centres 65–70 mm apart.

Stereo prints can be viewed only by one person at a time, and it is therefore preferable to prepare transparencies or use colour reversal film so that the pictures can be projected. The stereo projector has two lenses to project two separate images of the stereo pairs set in special stereo mounts. Black-and-white slides can be projected in complementary colours, such as red and green, by placing filters over the lenses. The two pictures

are superimposed, but not quite in register, so that if each viewer is supplied with spectacles containing the same filters the correct picture can be presented to each eye.

Naturally, such a system cannot be used for colour slides. In this case, the projector lenses are covered by polarising screens (see page 173) set with their polarising planes at right-angles, The viewer wears spectacles containing similar screens, so that each eye can see only the picture that is projected with light polarised in the same plane. For this method, however, a special projection screen has to be used, because the normal screen would depolarise the light striking it.

Supports for the camera

There are many occasions when the camera needs additional support to ensure shake-free results. The tripod is, of course, the support most commonly used, but it takes many forms. At one time, when cameras were a great deal larger than they are now, the tripod was an immense wooden affair of extreme rigidity. Nowadays, it too often tends to be an ultra lightweight, spindly legged contraption that shivers in the slightest breeze. Make sure that any tripod you buy has a reasonable leg thickness, so that when fully extended the legs are completely rigid and show no tendency to bend or bow when you press down hard on the top.

The camera support on top of the tripod may be either a pan-and-tilt head or a ball-and-socket type. The choice is yours. The ball and socket provides the greater range of angles, but can sometimes be rather too small to lock positively. Examine the locking mechanism carefully. If it is a soft metal screw or similar arrangement, avoid it.

The standard size tripod commonly extends to 5 ft or more and may have a central column that can be cranked up and down for extra height. This column is often reversible, so that the camera can be supported between the tripod legs at almost ground level. That can be useful on occasions, but if you expect to do much work with a low camera position. you may prefer to buy one of the many miniature tripods that can so easily be slipped into

a pocket or gadget bag. These are handy for close shots of wild flowers, plants, etc, for table-top photography and on various occasions when they can be placed on a wall, car bonnet, or other convenient surface.

A camera clamp is also easier to carry than a large tripod. It takes a form similar to the G-clamp used in engineering and woodwork, but carries a ball-and-socket head on which the camera can be mounted. The clamp can then be fixed to a gate, chairback, table edge, etc. Actually, such a clamp is more likely to be useful as a support for a flashgun than a camera. If your flashgun has no tripod bush, you can obtain a bush-to-accessory-shoe adaptor.

Yet another form of support is the pistol grip, shaped rather like the butt of a pistol with a cable release built in so that the plunger is in the trigger position. This can give a steadier hold with moderately long-focus lenses. For really long lenses, some manufacturers supply a shoulder-supported gunstock type that enables you to aim your camera like a rifle.

At a push, a tripod screw fitting with a chain or length of string attached can steady the camera quite remarkably The screw is fitted to the tripod bush on the camera, leaving the chain or string dangling beneath for you to tread on in such a way that the camera has to be pulled hard upward to get it to eye level. There are monopods — one-legged supports that provide just that little extra steadying that brief time exposures might need — and chestpods that brace the camera against the chest, and sometimes double as miniature tripods.

Cable release

The purpose of the tripod is normally to hold the camera still, either because you wish to give a long exposure or because you are using a long-focus lens that is difficult to hand-hold. In such circumstances it is rarely advisable to operate the shutter release by the usual finger pressure. That could easily impart the very shake that the tripod is designed to avoid. It is better to use a cable release — a sort of Bowden cable that pushes a spring-loaded plunger out of a sheath to contact the

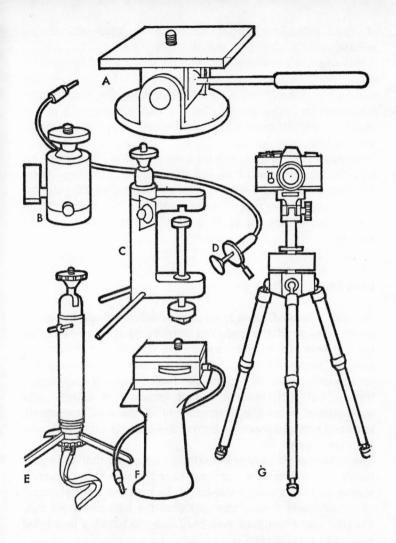

Camera supports: **a,** Pan-tilt head. **b,** Ball and socket-head. **c,** Camera clamp/miniature tripod. **d,** Cable release. **e,** Miniature tripod. **f,** Pistol grip. **g,** Tripod with centre column.

shutter-tripping mechanism. All SLRs are fitted with cable-release sockets, usually in the centre of the release button.

Cable releases are supplied in various lengths and for general work you should use a cable at least 10 in in length, so that it can be held loosely in the hand with its operating push button well away from the camera. The cable should never be pulled taut because that can easily cause tremors to be transmitted to the camera.

It is wise to buy a cable release with a locking mechanism, so that the plunger can be locked down for lengthy exposures. Shutters used to be provided with a T setting which held the shutter open, but that is now comparatively rare and the shutter has to be set to B and held open throughout the exposure.

Lens hood for flare prevention

Whether you need a lens hood or sunshade depends very much on the design of the lens. The purpose of a lens hood is to prevent rays of light from outside the picture area striking the lens obliquely and being reflected and re-reflected inside the lens to cause flare. Such flare can flatten contrast quite disastrously, but with modern coated lenses it is usually only encountered when the front element of the lens is relatively large and sits right out at the front of the lens with little protection from the mount.

The tendency nowadays is to design lenses so that as large a range as possible have common filter threads. This frequently means that the shorter focal-length lenses have front elements of considerably smaller diameter than the lens barrel. As they are also very often sunk well back into the barrel, a lens hood may not be necessary.

Where a lens hood is used, it must be of the correct size for the focal length of the lens. Where the angle of view of the lens is narrow (long focal length), the lens hood can and should be longer. If the same hood is used on a lens with a wider angle of view, however, some of the image forming rays coming from the edges of the picture are cut off and cannot enter the

lens. The result is vignetting – underexposure or non-exposure of the corners of the image area.

On the other hand, a too-short lens hood may still allow non-image forming rays to enter the lens and cause flare.

Adapter rings

There are many types of adapter ring for lenses. We have already mentioned the ring with double male thread, often called a coupling ring, to allow lenses to be fitted front to front for close-up work (page 128). We have also mentioned the similarly designed reversing ring (page 125) which allows a lens to be attached to camera, extension bellows or tubes with its back surface toward the subject.

Another form of adapter is the stepping ring, used to convert a filter thread to a larger or smaller size so that you can use the same screw-in filters on different lenses.

Lens attachments

The filter ring can take various other attachments, apart from supplementary lenses (page 125), soft-focus discs (page 174), prism lenses (page 176), star grids (page 176), etc. There are special vignetting attachments to provide the effect we have just mentioned as a fault with lens hoods. These can give the gradual fading-off-into-the-corners effect that was once very popular and can still occasionally be required for special effects. There are wide-angle or fish-eye attachments that increase the angle of view of the camera lens to provide unusual coverage and perspective.

There are mirror units that allow you to shoot at right-angles to the axis of the camera lens. This is an ingenious method of shooting an unsuspecting subject and one model at least has a dummy lens on the front to allay suspicion! You cannot, however, disguise the opening that shows the mirror facing the subject at 45° in front of the camera lens and you may find that it attracts attention instead of diverting it. Naturally, the mirror

also laterally reverses the image and makes the moving subject a little difficult to follow in the viewfinder.

The great advantage of the SLR is that you can see the effect of these various attachments on the image on your focusing screen before you press the release.

Flash accessories

The use of flash often calls for extra equipment. Most SLRs have an accessory shoe on top of the pentaprism specifically designed to accommodate a flashgun. There are still some models, however, with no such fitment and, if you wish to attach the flash to the camera, you have to obtain a separate flash bracket.

The simplest flash bracket is a straight metal bar with a tripod screw at one end to fix the bar to the underside of the camera and an accessory shoe at the other end to mount the flashgun alongside the camera. More sophisticated versions may be bent upward to mount the gun a little above the camera. They may also incorporate a tilting movement to allow the flash to be bounced from ceiling or wall. Some are combined with a handgrip at the side of the camera.

Where an accessory shoe is not fitted to the camera, some manufacturers supply a separate shoe that attaches to the viewfinder eyepiece and sits on the pentaprism top like the fixed type.

Later SLRs may have an accessory shoe with a central flash contact to accommodate cable-less flashguns. If your flashgun has no suitable connection but is fitted with a cable, you have to buy an adapter to convert the so-called 'hot shoe' type of accessory shoe to the normal coaxial fitting – unless, of course, the camera is also fitted with coaxial sockets.

If, on the other hand, your flashgun is the hot shoe type and the camera has only coaxial sockets, there is another adapter to convert the hot shoe to a coaxial socket. Some of these guns, however, also have a cable that automatically puts the hot shoe out of action so that it cannot short circuit when housed in the normal accessory shoe and connected to the coaxial socket.

There are many, many gadgets and accessories of all kinds for the SLR camera and you can quite easily become over-enthusiastic about the undoubted versatility of your camera. It is as well to remember, however, that most of these items have very limited uses and that you should think carefully before rushing out and buying them. There are too many photographers who have a most wonderful collection of filters, lenses and other attachments that have cost them a small fortune, but who still do the majority of their work with the plain, unadorned standard lens – and that could be of not very good quality.

SLR Subjects
Outdoors

Although this chapter and the next are headed 'SLR Subjects', it would be a mistake to think that there is any restriction on the type of subject that the SLR camera can cope with. The 35 mm SLR is probably the most versatile type of camera ever invented. We have already demonstrated its advantages of extreme portability, small format — permitting lenses of extremely long focal length to be used — enormous range of accessories and, of course, the supreme advantage of a magnified, correctly oriented view of the image formed by the lens.

These features make the SLR particularly suitable for certain types of subject and make it easier to use than any other camera for a variety of other subjects.

Nature's miniatures

The countryside is full of wild flowers and plants that make wonderful photographic subjects, but the average camera cannot take advantage of them, largely because of focusing difficulties. With the SLR, however, you have little difficulty in picking out a single bloom, plant, or even leaf. For many shots you can hand-hold the camera with a small extension tube (see page 120) behind the lens. If the subject is very small and you need a greater extension, you can support the camera on a miniature tripod.

All the equipment for such photography can, in fact, easily be carried in a gadget bag of reasonable size. The items that generally prove most useful are the camera and standard lens (particularly if it can focus very close without extension tubes), a pocket tripod, a set of extension tubes or small bellows and a small flash unit. Additional items carried by the real enthusiast might consist of a pair of scissors for snipping off excess foliage and a small folding reflector-cum-windshield. This can be a simple construction of pieces of cardboard or hardboard pieces taped at the edges so that it can fold into a small space, and with one side painted white as a reflector and the other a grey-green or other colour suitable for background use.

The reflector comes in very useful when you find interesting plants, fungi, etc, in dark corners of the woods. A single flash

may give too directional a light and the reflector can supply a much-needed fill-in, particularly if you are shooting in colour. Alternatively, of course, you might use it to provide bounced lighting.

If you have room to carry a further small item, you might consider the addition of a tele-extender for mobile close-ups

Apart from its normal use, it can be placed behind extension tubes or bellows. The effect then is simply to double (with a 2 × extender) the size of the image obtained with the lens and tubes or bellows. Thus, if you are working at 1:1 with the standard lens and a full set of tubes, you can add the extender *behind* the tubes, which has no effect on focused distance, and produce a 2:1 enlargement on the negative. At such degrees of enlargement, you will, of course, need to mount the camera on a tripod. This is where yet another accessory can be useful if your gadget bag is not already bursting at the seams. In many indoor set-ups for close-up work, you can often focus by moving the object toward or away from the lens. But outdoors that is not often practicable, so a focusing slide would be handy. This platform on runners is screwed on to the camera or bellows unit and the whole assembly mounted on the tripod. The camera can then be slid to and fro on the slide runners in a smooth, easy movement to provide accurate focusing.

Exposure can be rather tricky with outdoor close-ups. If the subject is in the open in normal lighting, there should be few problems; but the most interesting subjects are often in shady areas and need either long exposures or supplementary lighting. When you shoot in colour, you should preferably not let the exposure run beyond about one second because colour film is apt to produce rather odd results when the exposure is too long. This is due to failure of the reciprocity law. At exposures up to about one second, the effect on the film is near enough the same when you alter aperture and shutter speed in sympathy — i.e. 1/60 sec at $f1.4 = 1/15$ sec at $f2.8 = 1$ sec at $f11$, etc. When the exposure is longer, however, this relationship fails and the indicated exposure has to be increased still more. That is no very great problem with black-and-white film, but colour film has three emulsions and each one may react differently in these circumstances and cause colour distortion.

With colour film, therefore, it is advisable to bring the flashgun into play, rather than let the exposure run too long.

Long exposures with this type of subject are caused not only by the poor light conditions but also by the close-up requirements. The added extension increases the light path and necessitates extra exposure (see page 120). If you use a 2× tele-extender, you alter the focal length of the lens and thereby the relative aperture. In practice, that amounts to a two-stop exposure increase (see page 106).

Both these factors are, of course, taken care of automatically by the through-the-lens meter. Measurements with any other kind of meter have to be adjusted accordingly.

Whether through-the-lens or not, however, the meter has to be used intelligently. If you are shooting a small bloom, particularly in colour, against a comparatively dark background, the exposure meter is likely to be over-influenced by the dark tones and therefore recommend overexposure. The wisest course is to take an incident-light reading, if possible (see page 76), or to take a reading off a standard grey card or an approximation thereto (see page 81).

Flash outdoors and flash close-up both depart from the standards set for the calculation of guide numbers. There are no reflecting surfaces nearby to add to the general level of illumination and you need to open the lens up by at least one extra stop. If you use the flash on the camera or very close to the subject, the effect of fall-off due to the inverse square law (see page 84) is also exaggerated and the background may reproduce a great deal darker than you expect.

Landscapes and scenics

Most of us have probably been confronted from time to time by a scene of outstanding beauty. It might be a very different scene for different people, but it screams to be perpetuated in a photograph. So we photograph it – and when we see the result, the bubble bursts. The scene looks very ordinary, if not totally uninteresting.

The fault is invariably with the photographer. He fails to realise

the selective and interpretative ability of the eye and brain, as opposed to the bald, unwinking, all-embracing stare of the camera lens. He sees the rolling hills in the distance, the gently curving brook or stream or road, footpath, etc, the red-roofed cottages ideally placed, and so on. He fails to see the vast expanse of empty foreground the camera lens must encompass. He does not appreciate the miniaturising effect on the hills as compared with foreground objects. He does not foresee that the gently curving path or whatever it is cannot be fitted into the picture area as a dominating line.

Landscapes are difficult. The orthodox type (some people call them chocolate boxy) have to be very carefully put together and yet must not look artificial and devoid of life. They generally need a dominant feature, preferably at a point to which the eye is led naturally by the composition. Otherwise the eye is left to roam aimlessly over the picture and, finding no resting place, passes on to something else. The rules of composition are fairly straightforward, and there is no point in reiterating them here. There is good reason for them and there is little point in departing from them if you want to produce traditional landscape pictures – but, of course, there are other ways of treating landscapes.

Almost any subject can be presented as an arrangement of masses, shapes, lines, etc. Landscapes are particularly susceptible to such treatment. Trees, bushes, fields, buildings may appear in one scene in small, self-contained groups and can be presented as masses of different tonal value, either by shooting in suitable lighting or by adjusting exposure and processing to alter the contrast. On the other hand, trees and hedgerows may be in straight lines. Similar lines may be formed by ploughed fields, rows of buildings, fences, lines of telegraph poles or electricity pylons. Then the landscape picture can be dominated by these features to form a pattern of lines that makes a better picture than the arrangement of masses of which the lines are a part. Again, increased contrast can emphasise the pattern.

The term scenics is more all-embracing than landscapes, taking in pictures of built-up areas, village scenes, sea and waves coastline and cliffs and so on. These are the subjects for the holidaymaker, traveller, camper and other people who like to

get out and about. Many such people are quite satisfied with the most mundane presentation of their subject, rarely making any attempt to seek out the individual appeal or interest of the particular area or subject. You will generally obtain a better picture, however, and avoid the inevitable monotony of general views, by simplifying the subject and concentrating on single buildings, features or other aspects. The people, their mode of dress, their work, etc, may be the most interesting feature of one area, while the cobbled streets, or the thatched cottages, or the rows of slate roofs may be the mind-jogging elements of other places.

People at large

People are fascinating. Everybody takes pictures of people at some time – even if only of friends, relatives and children. The SLR is of particular value for any pictures of people, whether they are formal portraits, candids, groups, long-shots or whatever. The big screen image enables you to see expressions clearly and to compose the formal portrait with care. The interchangeable lens facility lets you stand well back from the subject or even to shoot from a considerable distance and still be able to watch your subject's facial expression.

If you are unduly bashful, you can attach an angle finder to the eyepiece of some SLRs so that you can face at right-angles to your subject. That, however, leaves the camera lens still pointing toward the subject, so perhaps you would prefer to place a mirror attachment on the front of your lens. This little gadget allows you to hold the camera to the eye in the normal way, but the view in your finder is the scene to the side of you, parallel with the lens axis.

These subterfuges should be avoided, if possible, and, moreover, you should not habitually use a very long-focus lens for this type of work. The long-focus lens always betrays itself by the typical flattening of perspective at long range, and the picture loses impact from its lack of intimacy. If the subject is modelling willingly, approach as closely as you can. For head and shoulders portraits, make sure that *only* the head and shoulders

appear in the viewfinder, so that you do not have to enlarge a mere portion of the negative. If you want a full-length picture, leave only enough space at top and bottom to avoid a cramped appearance.

For the more or less formal outdoor portrait, you can choose your lighting and even supplement it if necessary. As a general rule, avoid direct sunlight. Huge though the sun is, it is so far away that, to us on earth, it is almost a point source and accordingly it casts heavy, sharp-edged shadows. These shadows can blacken eye-sockets, illuminate one side of the face much more strongly than the other, throw disfiguring shadows from the nose, eyeglasses, hat brims and so on. Move your subject into the shade or shoot while the sun is obscured by clouds. The lighting is then much softer and the shadows just right for modelling the features without throwing black shadows.

Lightly cloud-obscured sunlight is ideal for colour portraits, whereas direct sunlight might cause paler colours to bleach out and dark colours to reproduce as black or even a purple or green.

Taking your subject into the shade when you use colour film is a little more tricky, particularly if the sun is shining strongly from a clear blue sky. Then, nearly all your light comes from the blue sky, and the excess blue shows in the slide or print. If you are using colour negative film for prints, this blue cast is not too great a fault because it can be filtered out in printing. If you use colour slide film, however, it is advisable to use a pinkish or straw-coloured haze-type filter to absorb the excess blue.

A different type of colour cast – the partial cast – is much more serious and must be avoided unless you are seeking special effects. If your model sits on the grass or stands near a strongly coloured wall or wears a broad-brimmed coloured hat, the colour from these objects will almost certainly be reflected on to her face or body. You will not normally see this reflected colour, but if you are aware of the possibility and look much more carefully, you *will* see it and must take steps to avoid it.

The formal portrait has its uses, but you generally obtain much more satisfying pictures of people by shooting more casually –

while they are working, playing, talking, reading, etc. With care, such shots can be just as much posed portraits as the more formal type, but they can look a great deal more natural. Do not call for gross alterations in the natural pose, simply because the lighting is not suitable or you cannot see the face clearly, for example. Take the onus of this alteration on yourself by changing your viewpoint or even your lens and making only slight adjustments to the model's position.

If you are shooting 'off-the-cuff' and cannot control the model at all, the choice of lens and viewpoint is even more important. If possible, take your time to consider the possibilities unobtrusively and bring your camera to the shooting position only when you are reasonably certain you have found the right angle.

When shooting people in crowds, in the streets, in public places such as railway stations, etc, it is often a good idea to fit a wide-angle lens to your camera. The short focal length, coupled with an aperture of, say, f5.6 or f8, allows you to take liberties with your focusing because, even at a range of a couple of metres (6 or 7 ft) you have considerable depth of field. Similarly, the wide angle enables you to shoot rapidly, without framing the subject very carefully. You can even 'shoot from the hip', so to speak, without raising the camera to the eye at all. This means, of course, that you rely on being able to enlarge only a part of the image, but that is quite feasible with modern films and lenses when the subject does not demand the ultimate in image quality.

Sports and pastimes

Most communities have a reasonable programme of organised sporting activities, whether professional or amateur, and the specialist in this field should not lack opportunities for finding suitable subjects.

The games played in stadia or other large arenas are not always easy to photograph. Only official photographers are allowed to approach the playing area, and in some cases they are the only people allowed to take photographs. Even when you can take

Below, and pages 202, 203, 204: People are different, but they all look at the camera. There is no reason why they should not. They are all aware that they are being photographed, and the eye-to-eye relationship adds life and immediacy to the picture — *Olaf Kurbjeweit, Francisco Hidalgo, Leslie Turtle, P. C. Poynter.*

Page 205, top: Inquisitive youth can usually be relied upon to make a picture. Centrally placed in this orderly welter of lines and shapes, these tiny figures achieve a striking dominance — *I. Rosenberg, Harrow School of Photography.*

Page 205, bottom: Cats are no less inquisitive than children and can be just as effectively caught in rather incongruous surroundings — *Harald Mante.*

Page 208: Grab shots such as these, sometimes called candid photography, depend on rapid inconspicuous use of the camera. Facial expressions are usually the making of the picture and they must be caught before the subjects realise that they are being photographed – *Hartmut Rekort, Olaf Kurbjeweit.*

Tonal compression provides a heavy oppressive effect of mist, gloom and threatening skies closing in on the setting sun – *Michael O'Cleary.*

Opposite: Tone separation treatment of a strongly-lit original scene shows up the awesome nature of natural phenomena – *Harry Paland.*

up a standpoint on the perimeter of the area, say a football pitch, you still face the difficulty that most of the action will probably take place at some distance from you. You can overcome that by fitting a long-focus lens to your camera, but then you cannot shoot the action near to you. It is completely impracticable to change lenses as the action moves to and fro, so, if you decide to carry a long-focus lens as well as the standard lens, you need two cameras.

Even then, you will generally find it best to prefocus the cameras so that they cover two zones as deep as you can make them by choice of aperture and focused distance. Then concentrate on shooting incidents within those areas.

This technique suits many sports, such as show jumping, athletics meetings, tennis matches and so on, and can produce quite good results when you are forced to shoot from the public enclosures or from outside the actual playing area. If you are allowed into the arena, as you may well be at local gymkhanas, athletics meetings, etc, it is generally better to approach the subject as closely as is safe or permissible. The close approach nearly always increases the impact of the picture, particularly where leaps, jumps, falls and so on are involved, and can also improve the quality by restricting the enlargement ratio on subsequent printing. When you have to shoot from a distance, the interesting part of your picture often occupies only a small part of the image area.

Buildings and architectural features

There are certain conventions in the photography of buildings that it is just as well to follow, unless you have particular ideas of your own about the subject and its presentation.

A basic rule is that you photograph the normal four-sided building at an angle that shows its front and one side, with the brighter light on the front. This may mean that you have to wait for suitable lighting conditions.

There are various reasons for this arrangement, both aesthetic and practical. It is reasonable, for instance, to show that the subject has depth, rather than to picture just one side of it

head-on. The diagonal lines formed by the angled viewpoint are generally more interesting than the series of horizontal lines produced by the head-on view.

The brighter light on the front is an acknowledgment that the front is generally the most important part of the subject. The rule implies, too, that the photography of buildings requires directional lighting. This is normally true because flat lighting tends to obscure many interesting details, and to eliminate the shadows under eaves, window sills, etc, that serve to emphasise those features.

For orthodox photography of buildings, you have to hold the camera straight and level. It is vitally important that you do not tilt it up or down. If you do, the vertical lines forming windows, doors, wall edges, etc, cannot be reproduced as verticals, and your picture shows them converging toward the top when you tilt the camera upward or toward the bottom when you tilt downward. To ensure that vertical lines in the subject are reproduced parallel in the photograph, the back of the camera must be parallel with those lines.

Inevitably, this requirement means that you cannot include all of a tall building in your picture unless you move a long way back from it and also include a lot of unnecessary foreground. Sometimes, you cannot move very far back. A possible solution, then, is the use of a wide-angle lens, when the wider angle of view might just bring in the top of the building – but also more foreground. If you cannot move back far enough even for a wide-angle lens to include all the building, there is no solution to the problem. To bring in the top of the building. you have to tilt the camera upward, and that means that its vertical lines will converge toward the top and the building will appear to lean backward. But you do not always require orthodox representations of buildings. The steeply angled viewpoint can create an impressive picture – as opposed to a realistic record.

There are many occasions when the main interest is a feature of a building – a door, window, ornament, etc. On these occasions, the interchangeable lens facility is often invaluable. You may want to picture a relatively small feature high up on a building and your job is made a great deal easier if you can put a long-focus lens on the camera. The long-focus lens is also

helpful when you want to lessen the convergence of verticals in, perhaps, a first-floor window. The longer the shooting distance, the less the camera has to be tilted and the less the convergence. On the other hand, there can be occasions when the particular feature you are after is located in an awkward position that only a wide-angle lens can enable you to get at. This generally means that you shoot from very close range and, if your subject is flat or nearly so, you have no problem. If it is three-dimensional, however, you will inevitably encounter some distortion. Perspective distortion is an ever-present danger in all types of architectural photography, because the viewpoint inevitably influences the apparent shape of the subject. A very close approach to a corner of a building makes that corner huge in the reproduction in comparison with another corner. The building is then made to look much longer or deeper than it really is. At the other extreme, a shot taken at the same angle with a long-focus lens can make the building look as if it has very little length or depth.

Ideally, you should use the lens that ties up correctly with the expected degree of enlargement for the final image and the distance at which that image will be viewed. If, for example, you expect to produce prints of about 16×20 in size and you expect them to be viewed from about 7 ft, you should, ideally, use a lens of about 135 mm focal length, because the ideal viewing distance is the focal length of the taking lens multiplied by the degree of enlargement.

Naturally, the ideal is not always possible, but it is worth keeping in mind.

Birds and animals

Most photographers are attracted to bird photography at one time or another, but few pursue it for very long because it is by no means easy, especially with non-reflex cameras. There are not many birds that you can approach closely with a camera and, once you get more than few feet away, the image of the average small bird that you obtain with a standard lens is

extremely small. It is difficult enough to see on the reflex screen. In the non-reflex viewfinder it becomes almost invisible.

With the SLR, however, you can put a long-focus lens on the camera and enlarge the image in the viewfinder as well as in the final picture. Indeed, with very long-focus lenses you can pick out a bird that you can barely see with the naked eye and make a careful assessment of the right moment to shoot.

Nevertheless, very long-range shooting is not a good method of bird photography. It generally gives far too little depth of field and makes focusing extremely difficult. The naturalist generally prefers to shoot from closer range, so that he can present both the bird and its natural surroundings without the flattened perspective and differential focusing of the long-range shot. That may call for the use of a 'hide', but we do not intend to go into that kind of specialist operation here. A hide is generally constructed over a period of many days, and its use implies that the photographer has studied his particular victim with care (probably for a considerable length of time) and has a thorough knowledge of his habits.

The casual bird photographer cannot do that, but he can observe some of the naturalist's precautions by remaining perfectly still if he does spot a subject and bringing his camera into position as slowly and as inconspicuously as possible. Some birds are much tamer than others, of course, and you can attract all sorts to your own garden by putting out food for them – preferably on a flat surface raised from the ground and sited near a fence or tree on which the bird can alight to spy out the ground before approaching the food. This gives you an opportunity to study the birds and their habits and to decide how best to photograph them.

While a long-focus lens is usually necessary when photographing birds, because of their small size, it is often needed for animals for precisely the opposite reason. You *can* photograph a horse, for example, with a 50 mm lens, but if you approach as closely as that focal length allows you to and if you shoot it head-on at a slight angle, you will picture a very peculiar animal. The same can apply, of course, to many animals, smaller or larger than the horse. This is the old question of perspective distortion again. The close viewpoint makes the features of the

animal closer to the camera look much larger than those parts farther removed. The only remedy is to shoot from farther away and, if you want the animal to fill the frame, that generally means changing to a long-focus lens.

For the town-dweller, animals outdoors are now almost entirely confined to domestic pets and those kept in zoos. The horse is becoming a rarity, except on the racecourse and showground.

Zoo animals rarely make very good pictures, if only because practically every animal in every zoo has had miles of film exposed on it. Apart from that, despite the tendency to 'open' zoos in recent years, conditions do not really favour photography. The beasts rarely look very happy in their artificial surroundings and it never seems to be possible to attain exactly the right viewpoint, with the right lighting, background, foreground and all the rest of it.

Domestic pets are more rewarding and, if they are your own, they are even occasionally amenable to a certain amount of 'direction'. Cats, for example, particularly young ones, will invariably oblige by chasing balls of paper, cotton-reels, etc. Older cats are often quite happy to be arranged in a patch of sunlight. Dogs are real performers, and some will go through their party tricks *ad infinitum* – almost as if they knew that you had not a hope of shooting it right first time.

Most bird and animal photography calls for a fast shutter speed, not necessarily because of any movement actually taking place at the time, but to allow for the unexpected sudden movement. Birds, of course, are on the move all the time, but even cats, dogs and horses can move heads, ears, tails, etc, suddenly and unexpectedly. It is well, therefore, unless the light is particularly bright, to use a fastish film – about 400 ASA – so that you do not have to open the lens up too far.

SLR Subjects
Indoors

Indoor photography always raises lighting problems. Conditions are rarely encountered, especially in private houses, where the lighting is evenly spread over the entire room. It is usually highly directional and often overhead – the kind of lighting, in fact, that you would never set up for a portrait.

People at home

Nevertheless, if your intention is to present people in their normal surroundings, there is a lot to be said for leaving the lighting alone or only augmenting it when absolutely necessary. One drawback with overhead lighting, for example, is that it often illuminates the top half of a person much more brightly than the bottom half. The head and shoulders may be satisfactorily lit, while the legs and feet disappear into virtual darkness. If the legs and feet are particularly attractive, that may be undesirable, just as it undoubtedly will be if the intention is to show the full length of a party dress. If the subject is knitting, however, or helping a child to read, or listening to a record player, it is probably only the upper half of the body that is important. The rest can be allowed to fade off into comparative darkness.

The inverse square law gives some indication of the conditions that favour uneven lighting. If the overhead lighting is a single lamp at normal height, for example, the fall-off is likely to be considerable. If the light source is large – as in a cluster of lamps, a large fluorescent, an illuminated ceiling, etc – the fall-off is not likely to be so noticeable.

If you feel that you must introduce supplementary lighting to combat the fall-off, it is easier to make it general, rather than localised. If you use flash, for example, you are likely to get a better result by tilting the flash head toward the ceiling or a nearby wall so that an even flood of light is radiated over a wide area.

This type of bounced flash lighting is particularly suitable when you shoot party scenes. If you use the flash direct, you strongly illuminate nearby people and furniture or fittings, while throwing those only a few feet behind them into Stygian gloom.

That is fine, perhaps, if the subject is 'performing' in some way, but if the shot is intended to convey the general party atmosphere it is not a very successful form of lighting.

Flash bounced in this fashion is relatively weak, but that is not a bad thing. You generally need to concentrate the interest on a particular person, so a largish aperture coupled with close-range shooting is ideal. Depth of field is restricted and your subject can be differentially focused without entirely losing the background characters and atmosphere.

In colour, flash mixed with tungsten lighting in the room might produce some strange results; but in such shots accurate colour rendering is not essential and quite large variations are generally acceptable as natural to the party atmosphere. If you must have reasonably accurate colour rendering, you have to use a flash sufficiently powerful to overwhelm the room lighting or you have to turn the room lights off.

When you shoot by day indoors, the use of window lighting raises an infinite number of possibilities. The character of window lighting varies enormously with the size of the window, the nature of the curtain material, the distance of the subject from the window, the camera position relative to the window, and so on. Try the various effects provided by shooting into the room with your back to the window, across the window with the subject on the other side of the room, toward the window so that your subject is backlit ,and so on.

Light through a window is directional, and the smaller the window the more directional the light. On the whole, however, a large window gives a resonably even flood of light that casts relatively soft shadows, provided the illumination is from a bright sky rather than from direct sunlight. If the camera is between the subject and the window, the lighting is even and reasonably shadowless. If the camera is farther into the room, it naturally sees more of the parts of the subject that receive no direct light from the window. It therefore obtains more modelling in the subject, but, particularly in colour, may lose too much detail in the shaded parts. Again, these matters are affected by the size of the window, the size of the room and the nature of the walls as reflecting surfaces.

If you feel that the shadows need to be relieved, the simplest

method is to place a large reflecting surface to pick up some of the window light and reflect it into the shadows. For colour work, the reflector must be white or neutral coloured. Sometimes, you may be able to move your subject toward a wall to provide the necessary reflector.

An alternative is to use flash to provide the required shadow relief. In all cases when you use flash and colour film indoors, you must use daylight colour film for correct colour rendering. You use artificial light film only when the lighting is entirely from tungsten lamps. In fact, artificial light colour films, according to type, are intended to be used only in photoflood or studio lighting at much higher wattages than are normally met with in domestic lighting. Accordingly, domestic lighting throws a rather yellowish cast over pictures taken on this type of film, but the cast affects only the weaker colours and is not necessarily objectionable. It can be corrected to some extent, if necessary, by placing a very pale blue filter over the lens.

Rooms and their contents

Film and television cameramen can present a very satisfying picture of a whole room because, apart from the fact that their cameras can move around, their rooms do not usually have four walls. They can shoot from outside the room and cover almost every inch of it.

When we, with our still cameras and four walls, try to provide impressive pictures of our newly decorated lounge or fitted kitchen or what have you, we run into problems. How *do* you show a significant part of a room measuring, say, 18 × 12 ft, when the camera has to be inside that space? How do you avoid perspective distortion and how do you get it all evenly illuminated and sharp?

Well, lighting is not too difficult if you distribute photofloods or other lamps carefully around the room, hiding them from the camera behind chairs, curtains, etc. Then, if you have enough light, you can use a small enough aperture to let the depth of field take care of the all-over-sharpness question. You are, after

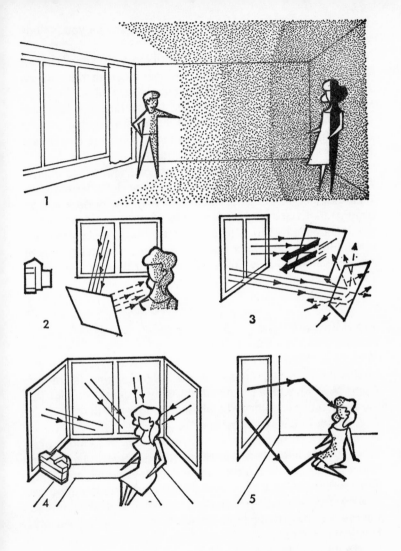

Window lighting: 1, Light from the window loses strength with increasing distance. 2, A reflector can be used to lighten shadows. 3, A shiny reflector can form an effect light. A matt reflector acts as fill in. 4, Within a bay, the model can be lit from several directions. 5, Reflecting surfaces can throw colour casts when colour film is used.

all, going to use a wide-angle lens. How else can you include a reasonable amount of the room?

That means, however, that you are going to include parts of the room and its furniture that are very close to the camera. So you are still faced with perspective distortion, and there is very little you can do about it. No matter how carefully you choose your viewpoint, the closer subjects are going to look bigger than they should and those farther from the camera are going to look much too small by comparison.

All you can do is to try to avoid direct comparisons. You might have to place the camera near to a table or desk, for example. That may not be too bad. The size of the table or desk will be exaggerated, but it might not be obvious. If, however, you place a telephone, or even a teacup, on the desk, the perspective distortion is immediately apparent because that telephone or teacup will look many times bigger than a door or window or chair on the other side of the room.

Providing the light

When you decide to augment the light indoors, you have the choice of domestic lamps, special photographic lamps, or flash. We have dealt with flash fairly extensively already. Domestic lamps we have barely mentioned, but they have, in fact, plenty of uses in photography.

When you wish to photograph a whole room, or as much of it as your wide-angle lens will allow, it is generally advisable to boost the lighting in the corners, under tables and in any dimly lit areas. Otherwise, these parts of the picture tend to reproduce as very dark patches — much darker, indeed, than they look to the eye. You have to overlight a room to make a picture of it look reasonably natural.

It is quite feasible to use relatively low-power domestic lamps for this lighting because the length of the exposure is generally unimportant. You can stop the lens well down and use a slow shutter speed with the camera on a tripod. Some ingenuity may be needed to ensure that the lamps or their electrical leads do not show in the picture area. The lamps, generally in reflectors,

can be hidden behind large items of furniture, in fireplaces, behind drapes, etc. The leads, too, can pass behind drapes, under carpets or, as inconspicuously as possible, along the edges of the floor.

The advantages of domestic lamps are that they are easily obtainable, they do not consume much electricity, and the light they give is relatively soft and easily handled. Their disadvantage is that no colour film is designed to give correct colour rendering in the type of light they provide and even filtering is no great help.

So, if you want your interiors in accurate colour, you have to use photofloods and artificial light film or, if you have no access to the electricity supply, you must use flash and daylight film. The placing of photofloods or extension flash heads is no different from that of domestic lamps, but it is as well not to place photofloods too close to drapes or furnishings if they are likely to be left burning for very long. Their electricity consumption is high and they generate considerable heat.

Be careful, too, that you do not overload the electrical wiring. A No. 1 photoflood consumes 275 watts, and it is not advisable to run more than four of them from a 5-amp lighting circuit. The normal 13-amp power circuit will take about ten such lamps.

These figures are applicable to the normal 240-volt supply used in the U.K. Where the supply is different, the calculations have to be made according to the formula:

$$amps \times volts = watts$$

Thus, a 5-amp circuit on a 110-volt supply will accommodate lamps rated at up to 550 watts total.

Remember, too, that it is the wiring that is the danger, not the plug or socket. It is no use replacing the 5-amp socket on a 5-amp supply with a 13-amp socket. If you try to draw more power through the wire than it is intended to take, it gets hot — very hot — and can cause fires where the wiring is close to floorboards, lath ceilings, etc.

Photofloods give a lot of light, but they are not easy to handle. Their light tends to be harsh and to create heavy shadows. Filling in those shadows with other lamps sometimes leads to overlighting and is, in any case, difficult to achieve when lighting a room in the way we are at present discussing.

Babies and children

Babies can pose quite awkward problems – especially very small babies. You have to approach them quite closely if you are using the standard lens and, as always, you then face the possibility of perspective distortion when legs or arms stick out toward the camera. Fortunately, the face is usually fairly flat. Features are only just beginning to form and are not too prominent.

In general, babies are best photographed with a lot of light from a large source. You *can* take low-key pictures of babies, but if you are taking the picture for the mother, she will not generally appreciate it. It is not advisable to use photofloods with very young babies because they may stare into them for prolonged periods. Flash is a better proposition, or large diffused lights at a reasonable distance.

The formal portrait look – child, adult or baby – has been out of favour for some time, but again, you have to consider the purpose of your picture. If it is for your own pleasure or for exhibition, you might be seeking realism – or a reasonable approach to it. Dirt, dribble, biscuit crumbs, uncombed hair, untidy clothes and similar horrors may be exactly the effects you are looking for. If the picture is for the mother or for publication in womens' or mother-and-child type magazines, it may have to be a great deal more antiseptic.

Making an attractive picture out of a very young baby is, in fact, extremely difficult. It is rather like trying to pose a melting jelly. The mother, surprisingly, will very often not want to appear in the picture herself. She wants a picture of her baby itself in all its solitary glory and obvious glowing character – although to you it will probably be about as full of character as a suet pudding. So you try the various alternatives of propping it up and lying it down. Inevitably, it flows into an ungainly looking lump or simply falls over – sideways, backwards, or flat on its face. And nearly always, contrary to popular opinion, in total silence and with an apparent total lack of interest in the proceedings.

Once the baby has sufficient strength to lift its head – even for a moment or two – you can, at least, lay it prone and try to

attract its attention. The moment the head lifts, shoot and pray that the expression is not totally demonic. You will probably only get the top of the head, anyway, as the effort proves too much.

Eventually, however, the baby is old enough to play with toys, draw, write, read, etc. Then you can take reasonably natural pictures. The best method is generally to follow the child as unobtrusively as possible with the camera and shoot a lot of film. Depending on the type of picture you are after, you should normally shoot in the light available, reserving flash for the occasions when it is absolutely necessary. Such occasions should be relatively few if you have an $f2$ or even $f2.8$ lens. If you are shooting primarily at one particular child, full aperture with a 400 ASA film should cover most eventualities.

Groups of children may be more difficult, but even then it is better to do a little discreet direction, if possible, rather than use flash to obtain the necessary depth of field. Flash in these circumstances can rarely look like natural lighting and it is a pity to introduce any artificiality into photographs of children.

How the SLR developed

The SLR camera, as we know it today, is a comparatively modern development; but the reflex principle can be traced back even to the camera obscura. 'Reflex' simply means 'using the principle of reflection', and many large-format cameras made before 1900 (the first patent was by Thomas Sutton in 1861) had a mirror angled at 45° behind the lens to throw the image-forming rays from the lens on to a ground-glass screen set horizontally in the top of the camera.

Early reflex designs

The older cameras using this principle were, however, terribly cumbersome. The mirror was large and, for 'instantaneous' shooting, had, in most models, to be snatched away from behind the lens by a strong spring before the shutter opened. The camera tended to shake violently even before the mirror thumped to the end of its travel. Various damping devices were used, but they were rather primitive and had very little effect.

There were some semi-automatic models in which the shutter-release plunger raised the mirror mechanically before the shutter fired and allowed it to drop back into position and to be held by weak springs immediately after the exposure. This was the forerunner of what came to be knowm as the instant-return mirror, but it was many years before the principle could be satisfactorily adapted to the much more demanding requirements of the 35 mm camera.

The first 35 mm single-lens reflex (so-called because the twin-lens reflex had been established for some years) was a far cry from the sophisticated instrument we know today. It was the Kine Exakta which appeared in Germany in 1936-7, using exactly the same principle as the older cameras, but, naturally, in a considerably scaled-down form. It became popular, but had too many disadvantages to be a runaway success. The viewing screen was, of necessity, the same size as the image area (24 × 36 mm). It was not easy to compose the picture or to focus it critically on such a small screen and the lateral reversal of the image did not help. Additionally, a new way of thinking was needed when the camera was turned to provide an upright

format – when the image became upside-down but the lateral reversal disappeared.

Advent of the pentaprism

Image reversal was overcome with the development of a specially shaped, five-sided prism (now universally known as the pentaprism) which was placed on top of the viewing screen and incorporated a magnifying eyepiece focused on the screen image. The multi-reflecting surfaces of the pentaprism present a correctly oriented image, no matter how the camera is held. Moreover, a magnifying eyepiece is fitted to give the impression of viewing an almost life-size image when the camera is fitted with the standard lens. If you view with both eyes open, you do not find an uncomfortable disparity between the sizes of the images seen by each eye.

The pentaprism, originally an attachable extra, was first provided as an integral part of the camera in 1948, when the Contax S made its appearance. It eliminated most viewing and focusing problems, but there were still some awkward operational features that prevented the SLR from offering any real competition for the established rangefinder models.

Disadvantages of early designs

Mirror operation was still cumbersome. The mirror flew upward to cover the screen and exclude light just before the shutter was released. Thus, the viewfinder image was blacked out fractionally before the picture was actually taken and remained blacked out until the mirror was manually wound down again into the 45° position. This action was coupled with the winding-on of the film, which, as in many other cameras, had already been linked with the shutter cocking, exposure counting and double-exposure prevention mechanisms.

A further slight drawback common to all cameras with a focusing screen was that the viewfinder image was not particularly brilliant and tended to become darker in the corners.

To see the image clearly and to focus accurately, it was necessary to open the lens up to its fullest aperture. Then, when you were ready to shoot, you closed the lens down to its predetermined setting – if you remembered. It is true enough that the SLR eliminated the danger of shooting with the lens cap on, but many users shot far more pictures at full aperture than they ever intended.

Improvements in screen brightness came first from the use of embossed plastic, instead of ground glass, and later from the addition of a special kind of condenser lens known as a fresnel screen – developed from the type of lens used in lighthouses. Neither of these was of any great benefit for fine focusing, but they made the image much easier to see, while the fresnel screen extended the brightness right into the corners.

The 35 mm SLR, therefore, remained until the 1950s a camera with many advantages in specialised work, but of no great value for run-of-the-mill, day-to-day photography. It was larger – often a great deal larger – than existing rangefinder models and much slower in operation.

Instant-return mirror

In the 1950s, however, Japanese camera manufacturers – and the Asahi company in particular – took the original German invention and really went to work on its drawbacks. The modern 35 mm SLR dates from that time.

The first disadvantage to be tackled was the manual operation of the mirror – although many users felt that this was really no great handicap, compared with the necessity for constant opening and closing of the diaphragm. However, in 1954, the Asahi company brought out the camera that spearheaded the attack by the 35 mm single-lens reflex on the mass market. This was the Asahiflex IIB, forerunner of the present Asahi Pentax range. This camera embodied the first instant-return mirror in a 35 mm camera. The mirror flipped upward as usual just before the shutter began to move, and returned instantly to the 45° position as soon as the shutter had closed.

The original design has been considerably adapted and

improved upon since then, mainly to reduce the incidence of camera shake caused by the mirror action. This cannot be entirely eliminated, and many cameras (mainly in the higher quality range) are still fitted with a mirror lock so that the mirror can be locked in the up position when critical work is undertaken. This provision is also occasionally necessary when special wide-angle lenses are fitted to the camera.

There was still no way of avoiding the viewfinder blackout while the shutter was open and this was still a disadvantage, but many felt that the instant ability to see another picture was preferable to the longer blackout of the previous system.

Automatic diaphragm operation

It was a debatable point at that stage because the lens still remained at the taking aperture and, if refocusing was necessary, had to be opened up manually. Thus, the value of the instant-return mirror did not become fully apparent for another five years when, in 1959, lenses made for the Nikon F were fitted with what was at first called an instant-return diaphragm, but later became known as the fully automatic diaphragm (FAD).

Many other types of semi-automatic diaphragm had already been produced. They avoided the necessity for closing the lens manually after focusing and viewing, but left the lens stopped down after the exposure, so that it had to be reopened manually if full-aperture viewing or focusing was necessary for the next picture. A version of this preset type of diaphragm remains popular with some cheaper lenses, particularly those in the long focal length range.

The usual preset mechanism is an aperture ring that can be pushed slightly along the barrel of the lens against a spring and turned to the required f-number. The diaphragm does not close down during this operation, so that the screen remains brightly illuminated right up until the moment you want to take the picture. Then, you simply twist the aperture ring as far as it will go and it automatically stops at the preset f-number position, this time closing the iris as it does so.

The fully automatic lens eliminated all manual operations

except, of course, the original presetting of the aperture according to exposure requirements. Once you had preset the aperture, everything was automatic; when you pressed the release, the iris closed down, the mirror flipped up, the shutter opened and closed, the iris reopened and the mirror came down ready for the next shot. A few designs did not fully overcome the snags, one of which arose because the automatic lens has to be controlled by a mechanism within the camera body.

This meant that two separate mechanisms were necessary — one in the lens and one in the camera. The two mechanisms had to mate when the lens was attached to the camera and had to be common to all the lenses designed for any particular camera. The simplest design, and one that is used for most screw-type lenses, consists of a spring-loaded pin projecting from the back of the lens and connected at its inner end with the diaphragm so that, as it is pushed inward, the diaphragm closes to a stop set by the aperture control ring. The pin is pressed by a 'pusher' mechanism connected to the shutter release. The snag arose when the connection between shutter release and 'pusher' was too simplified. A direct push simply meant that as soon as you let go of the release the pusher failed to push and the lens diaphragm reopened. Thus, if you let go of the shutter release during a brief time exposure, part of the exposure would be at full aperture.

Many automatic lenses became extremely complicated and tended to make some aspects of photography difficult. Some of them had no provision for manual operation at all. Others had only a hold-down or similar control to close the diaphragm briefly to its preset amount. This was adequate for checking depth of field, but not very useful if the lens was to be attached to bellows or extension tubes. Various remedies have been tried. Automatic lenses have been fitted with auto/manual switches, cable release sockets connected to the diaphragm for use with double cable releases, and so on. Some manufacturers provide a special ring with cable release socket to be attached to the back of the lens when it is used reversed or on bellows or non-automatic extension tubes.

By the 1960s, the 35 mm SLR was offering a real challenge to the rangefinder type of camera. It gradually added further

refinements, such as built-in exposure meters, rangefinder focusing spots in the screen, interchangeable screens on some models and an enormous quantity of specialised accessories. By and large, however, the early 1960s were years of consolidation rather than advance. Then, in 1964–5, things began to move again.

Eliminating the mirror

In 1965, for example, there appeared a camera that many thought would revolutionise the whole concept of the SLR. There were still many photographers who felt unhappy about the screen blackout caused by the mirror movement. They felt that there were occasions when, because they could not observe the picture right up to the moment of exposure, there might be a sudden change (expression in a portrait, for example) in the subject in the brief interval between the movement of the mirror and the opening of the shutter.

The Canon company apparently agreed, because they brought out the Canon Pellix, in which the moving mirror was replaced by a fixed pellicle – a very thin, semi-reflecting membrane – which passed most of the light through to the back of the camera, but peeled some of it off and redirected it upward to the viewing screen. Thus, there was no need for the reflecting surface to be moved out of the way while the exposure was made, because light also passed through it to form the image. Nevertheless, the Pellix was not really a success and no other manufacturer offered a similar model. The swinging mirror and its accompanying blackout remains supreme except in high-speed motorised cameras.

A parallel development looked like suffering the same fate as the Pellix. This was the so-called electronic shutter, which is, generally, an orthodox spring-operated shutter with a transistor circuit built in to control its timing. One or two 35 mm SLRs tried it – at least in prototype form – but at that time it had no real value for the popular camera. Early models were somewhat restricted in the higher shutter speeds, but provided a not particular useful range of extra slow speeds up to several seconds.

Through-the-lens metering

The third development of this period was much more important. It was the principle of through-the-lens metering, made possible by the development of the cadmium sulphide (CdS) photo-resistor as the basis of exposure metering in place of the selenium photocell previously used. The CdS light-sensitive surface can be considerably smaller than that of the selenium cell for a given sensitivity – so small, in fact, that it can be placed in various positions behind the camera lens without interfering with the normal operations of mirror, shutter, etc. Thus, readings can be taken directly from the light actually projected on the film by the camera lens, which has obvious advantages for cameras with a wide range of interchangeable lenses and other lens-attachable accessories.

The Topcon RE Super and the Alpa 9d brought TTL metering to the market in 1963–4, and the Prakticamat followed in 1965. Now, of course, almost every manufacturer of 35 mm SLRs has a TTL version and the principle has even been carried into the rangefinder camera.

Actually, however, the development of TTL metering was the final blow for the rangefinder camera. The SLR had not only overhauled its rival in ease and swiftness in operation (or very nearly so), but had also built up enormous advantages of its own in lens interchangeability, close-up and long-range work, elimination of parallax error, simple viewing and focusing arrangements no matter what lenses or attachments were used and, finally, a further development in TTL metering.

Early meters of this type took their readings through the lens after it was stopped down to the shooting aperture. Consequently, the viewfinder readout used almost exclusively was not easy to see in low-light conditions. The next step, therefore, was to introduce a shooting aperture simulator so that the actual diaphragm could stay at full aperture.

Gradually, all metering systems changed over to full-aperture reading with lenses designed for that purpose and stopped-down reading with other lenses and behind-lens accessories.

Automatic exposure control

There seemed to be little more that the reflex could do, but there was, in fact, one field that remained almost untouched. In the 35 mm non-reflex field there were many so-called EE models. The EE means electric eye and is applied to an automatic exposure type of camera in which aperture, shutter speed and film speed settings are linked with the built-in exposure meter operation in such a way that once film speed and shutter speed are set the meter controls the lens aperture automatically. This is a comparatively simple system when applied to a fixed-lens camera with blade-type shutter housed in the lens, and most manufacturers produced automatic-exposure models many years ago. SLRs with focal plane shutters were much slower to follow suit. They had used attachable or built-in meters of various designs from the earliest models and, indeed, all these types, culminating in the TTL versions of the 1960s were perfectly satisfactory. But further automation was inevitable and the meter-controlled aperture setting duly arrived. The original Konica Auto Reflex of 1965 had such a system before it even introduced its TTL meter. You set the film speed and shutter speed and the meter circuit automatically selected the appropriate aperture according to the lighting conditions. There were various TTL versions of this system, including separate metering heads for such interchangeable viewing system cameras as the Canon F1 and Nikon F. These use rather clumsy servo mechanisms to move the aperture control. Most systems were characterised by the fact that they needed special lenses to operate automatically.

This drawback was overcome by the Asahi design introduced in 1973 in the Pentax ES, which brought the electronic shutter back with a real purpose. Until then, the electronic shutter was something of a gimmick. It gave automatically-timed long shutter openings and more accurately timed fast speeds. It could give infinitely variable speeds and that was the feature seized upon by Asahi for the Pentax ES. This camera had an aperture-preferred automatic exposure system, which means that you set the aperture and the shutter speed is selected by the meter, instead of the other way round. The great advantage

is that any lens that can be fitted to the camera can operate the meter which is connected to an electronic circuit commanding the shutter operation. An incidental advantage is that a precise shutter speed is set to suit the conditions – even if the circuit calls for an exposure of 1/568 sec.

The two systems, shutter preferred and aperture preferred, now run side by side in the many automatic exposure cameras on the market. Each has its particular characteristic: the shutter-preferred system generally needs lenses specially adapted to it; the aperture-preferred system needs electronic circuitry to operate the shutter timing mechanism.

We might have been forgiven for thinking that we had now reached the end of the road in automated exposure. After all, we do not want the complete point and shoot facility that some non-reflexes had tried out years before – giving unknown and quite often wildly unsuitable shutter speeds and/or aperture settings. But there was more to come.

The CdS photo resistor, which had largely replaced the selenium photocell, began to give way to the silicon blue cell which, like the selenium type can generate a current when light falls on it. Unfortunately, the current is very small and has to be amplified, which calls for an amplifier circuit and a battery. That might have made it impracticable but for the fact that the silicon cell is much faster in reaction than the CdS photo resistor. It reacts instantaneously in good light and in a matter of seconds in the weakest light.

This rapid bright-light operation has led to a remarkable return to a more sophisticated type of stopped-down metering for automatic operation. The system introduced by Chinon in 1974 works basically on the principle that the fractional delay between the stopping-down of an automatic lens and the release of the shutter is sufficient for the silicon blue cell to make its reading through the shooting aperture and transmit the reading to an electronic shutter.

Then came the Olympus OM-2, which measures the light falling on the film or the shutter blind, according to the exposure duration, and sets the shutter speed automatically. This was followed by the Canon AE-1 with a shutter-preferred system and an extension of electronic circuitry to provide a very fast

response. The lens diaphragm closes down to the aperture determined by the meter circuit as soon as the shutter release is operated.

The spadework having been done by these two models, manufacturers began the fight to produce the model that satisfies everybody. There are models with a choice of metering systems – aperture preferred or shutter speed preferred, and every other variation that might be desired and can be created electronically.

What of the future?

So the 35 mm SLR has now become a thoroughly sophisticated and extremely versatile camera – very different indeed from the old Kine Exakta of nearly 40 years ago. Where can it go from here? It has banished its non-reflex cousin to specialised fields – cheap models, super-compact models, and fabulously expensive models – and has completely taken over the middle range as well as most of the highly specialised system camera field. Is there anything left for the SLR to do?

In the popular field there is, in fact, one feature that mars the performance of the SLR. Facilities vary from camera to camera, but the difficulty of synchronising a focal-plane shutter with flash at high shutter speeds still seems to be an insuperable problem.

There are focal plane bulbs, of course, and there are vertically moving shutters (and even one or two horizontally moving ones) that can synchronise electronic flash at about 1/100 sec – although most of them claim 1/125. But the speed available for ordinary flashbulbs is often farcical and manufacturers seem to have given up the struggle. It is becoming more and more common for cameras to be X-synchronised only, presumably on the assumption that electronic flash is so inexpensive nowadays that flashbulbs will soon die out. That could be a dangerous assumption.

Meanwhile, the 35 mm SLR user is strictly limited when he wants to use flash in daylight and, in fact, whenever the ambient lighting is of any significant strength. The problem seems insuperable at present and perhaps its solution is not vital, but no doubt it will come eventually.

INDEX